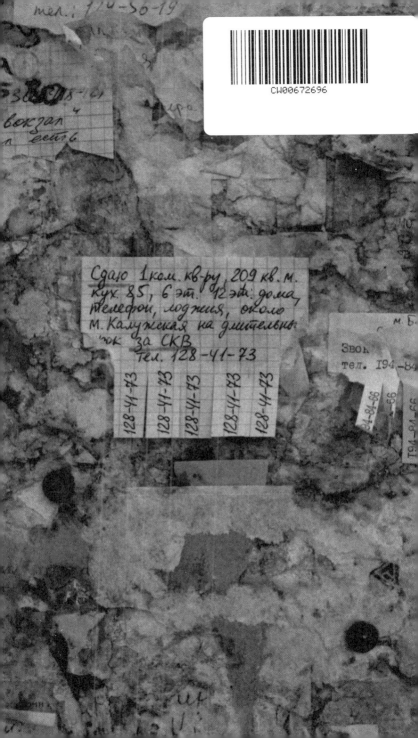

Notes from Russia

Notes from Russia

Alexei Plutser-Sarno

FUEL

CONTENTS

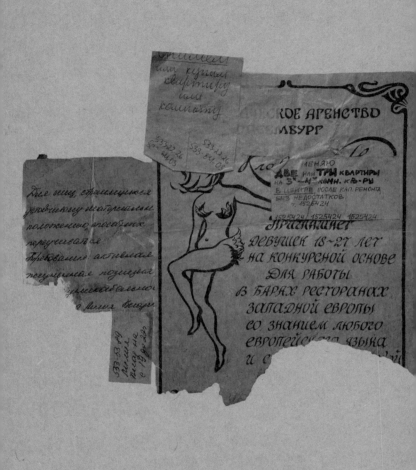

PORTRAIT OF THE RUSSIAN STREET

Notes from Russia is an attempt to paint a socio-psychological portrait of Russia based on anonymous street texts. Handwritten advertisements (ads), love letters, popular announcements, obscene scrawls, self-made warning signs, and even pieces of cardboard on string worn by beggars — all help build a unique image of the country. All of these street messages are completely authentic, and are published here for the first time.

Through the prism of this urban pseudo-folklore, I am trying to compose a picture of modern Russia, to describe the outlines of its social system, to determine some defining social and psychological features of its people, and to examine the curious mythical map of the world that resides in their minds.

People who post these messages and announcements on walls address a specific audience with a specific goal. At the same time, they reveal certain personal characteristics and social tendencies. They have concrete intentions: they are saying something, making explicit the state of their consciousness. Thus, these messages are social acts that originate in the sphere of so-called grey, informal social groupings and 'illegal' markets, which are particularly interesting in Russia. The very existence of these markets is a result of the insurmountable bureaucratic obstacles that these messages also clearly reflect.

Notes from Russia is taken from my personal collection of street messages, which I call the Museum of Ads and Announcements. I first began collecting them in the 1980s. Twenty years later, Russia is still covered with these anonymous signs and scribblings, most of which are overlooked by passersby because they are so ubiquitous. The study of such peripheries of culture, and verbal and visual trash, unsettles established cultural boundaries and definitions.

I have cited texts from other collections only if they were accompanied by photographic documentation. Ads marked with an asterisk, have been taken from O. Shapovalov's *Antireklama* (Moscow 2001).

On the streets, ads are stuck not only to purpose-built announcement boards, but also to anything that stands still long enough. Walls, garages, fences, gates, doors, bus stops, street lamps, entranceways, stairwells, subway cars, commuter trains: all are potential sites. Sometimes, the ads pop up in places inappropriate to their subject matter – on window panes, cars, litter bins. Professional beggars will wear their ads on their chests and backs. Roman Popov, a reporter from the *Komsomolskaya Pravda*, even found an ad on a thousand-rouble bill:

A hansome [sic] *guy wants to meet cool chics. Alexander. 17 yrs. 5'7".
I'm a boxer and a real hunk. Chics from 14 to 17 call 32-29-44
between 3 and 7 p.m.* ° [1996]

These, then, are 'street messages.' A street, however, is not just text, but also a series of visual images, colors, smells, textures, and spaces. A street is a *thing* which, within these pages, we are turning into a work of art. Indeed, pieces from the Museum of Ads and Announcements have been exhibited in galleries and museums across Russia. But this is their first incarnation as a book, and because of this I would like to introduce to the reader all the basic types.

МАШИНОПИСНЫЕ РАБОТЫ

Быстро, качественно, недорого

ыполнит для Вас студентка СПбГУ

я — телефону 218-45-94, Натали...

FROM ANNOUNCEMENTS TO LEAFLETS

Handmade public ads serve the same function as newspaper ads. In their subject matter and contents they are often very similar to graffiti, and completely indistinguishable from some forms of street distributed political leaflets. They are commonly written on scraps of paper and stuck to the walls of buildings. In addition, they are often covered with graffiti and extraneous drawings (the handiwork of strangers). Sometimes, the opposite is the case: ads are drawn or painted directly on walls and are indistinguishable from graffiti. People often write their own ads over the top of other ads, resembling an act of graffiti. The following ad was written by an Italian who gives French lessons:

Italian living in Paris will teach French, Italian, English, or Spanish for free in exchange for Russian conversation. 311-30-68.

it was handwritten over the top of another:

Typing.
Fast, high quality, inexpensive,
by a university student.
Please call 218-45-94. Natalia

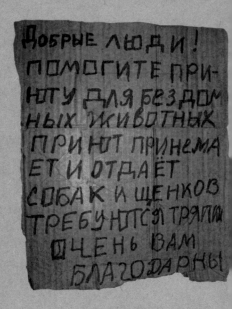

Ads that are stuck one on top of another are the rule rather than the exception. For example, this ad:

Moscow City Day

was glued to a poster that read:

Hot cereals
Soups
Pâté
Canned goods
Chocolate
Juice
Cottage cheese
Mayonnaise
Yogurt

The ads didn't completely overlap, appearing to complement one another.

Home-made ads often dwell alongside equally nonsensical official notices, handmade by service personnel of all ranks, often as single copies. Leaflets can also be found pasted onto the walls of buildings. The distinction between ads, graffiti, warning signs, leaflets, and other types of messages becomes blurred. There is, of course, a structural or typological distinction between them: a person writing on a piece of paper assumes a different attitude towards composing text than a person who writes on a fence.

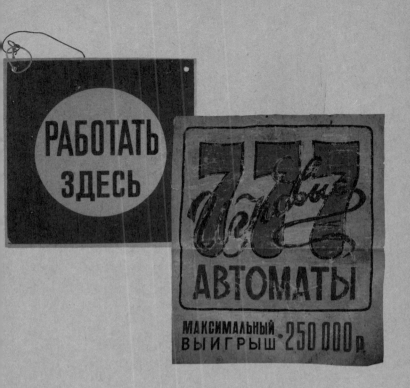

Ads are made on a variety of materials: metal, plywood, paper, plastic, even glass. The inscription:

Work Here

is reproduced on both metal and plastic. The dimensions of the ads also vary a great deal. The largest handmade ad I have in my collection was made on a 80 x 110 cm piece of paper and reads:

777 Slot Machines
Win up to 250,000 roubles!

The heaviest ad weighs six kilos, painted with oils on a piece of thick plywood. The smallest is made on a piece of paper that measures only 2.5 x 3 cm.

The material always influences the text it bears. In graffiti the balance is shifted toward the image and away from the text. Ads feature more detailed and extensive text and generally don't contain drawings. Warning signs are laconic. Leaflets, on the other hand, are wordy, and are often accompanied by an abundance of photographic images.

The majority of the ads presented in this book are home-made (although it is often difficult to isolate them from the larger context of street messages). In order to replicate the context and make it clear to the reader, I have included a number of home-made memos and graffiti which have been pasted onto official announcements and warning signs.

The notices range across many genres, from commercial correspondence, through to love letters, capturing the entire experience of Russian street life in all its originality. Exchanges, prohibitions, invitations, conspiracies, threats — they are a tangible form of social communication, occupying a unique position of unofficial, and more importantly, uncensored textual messages.

The notes can also elaborate and differentiate society, sifting it out into smaller groups. Some texts have their origins in folklore. Others play a significant role in the formation of religious sects, as well as social groups and political parties. A few lack any specific addressee, seeking only to secure the author's place in the social world — many would provide fertile ground for psychiatrists.

We should be cautious about applying the term 'popular culture' to this material. Although it presents a fairly exhaustive psychological portrait of ordinary people, it is a collection of the most disparate kinds of texts. What unites them is the manner in which they were made, and their provenance.

EMPLOYEES AND WAGES

Tough work, minimum wages, but boy is it fun!

Let me begin with a surprisingly short street ad, which is completely opaque to a Western reader:

Job $000.

The text advertises mysterious employment and says nothing about it, short of the wage, which amounts to zero dollars a month. This ad is, of course, ironic. Its purpose is to attract the reader's attention. To understand such ads, we need to clarify why Russians are enticed by low-paying jobs, or even agree to work for no money at all. An excerpt from another ad will give us insight into the social reality that results in this Kafkaesque absurdity:

Tough work, minimum wages, but boy is it fun!

It is common that these kinds of ads provide no details about the work in question. The reason for this is simple — no good can come of responding:

Urgent! We need SERIOUS, DETERMINED people for working under international contract. [1995]

УВАЖАЕМЫЕ ГОСПОДА!

Мы имеем честь предложить Вам работу художников-оформителей.
В Ваши обязанности будет входить поиск заказов и составление эскиза оформления витрин магазинов, указателей, вывесок для офисов и других видов наружной рекламы за определённый процент(5-10%).
Торопитесь! Набор ограничен!
Ждём Ваших звонков по телефону:
443-54-55
с 17 до 19 ч.

443-54-55 443-54-55 443-54-55 443-54-55 443-54-55 443-54-55 3-54-55 443-54-55 443-54-55 443-54-55 5

In your worst nightmare you couldn't imagine an 'international contract' that you would learn about from a handwritten ad on a dirty scrap of paper hanging on a wall in the street!

Russians are so naïve that they will compose (and fall for) ads that assume not only that the potential employee will do the work, but also find a client, draw up a contract, make the client sign the contract, and then hand over 90 – 95 percent of the profit from the deal to an unknown individual who passes himself off as an employer:

To whom it may concern. We have the honour of being able to offer you a position as a designer artist. Your responsibilities will be to seek orders and design display windows, direction signs, signs for offices, and other types of outdoor advertisement for a set percentage (5–10%). Hurry! Spaces are limited! Call 443-54-55 from 5 to 7 p.m.

Added later in pen:

Ask for Sergey.

Дети нашего города особенно нуждаются в хорошем питании

The swindlers play on the childlike expectations of people who want to be taken care of by paternalistic superiors, those who seek a quiet life, stability, and a secure future. However, these same people fail to understand that they are being fleeced. A similar approach is displayed by businesses advertising various products under the pretext of public concern. An ad for baby food reads:

Children in our city desperately need quality nourishment... [1994]

In Russia, money is not always the primary reward for labour. Instead of pay, people can be promised other forms of compensation. Government bureaucrats have always been privileged with special benefits, both official and unofficial, the fact that this ad explicitly declares that they have to pay for entry demonstrates how far their freedoms can extend:

Employees of FSB, MVD, UVD, GUVD, TNP, OMON, and other law-enforcement units, as well as 'servants of the people' [government officials] *of all ranks are admitted on general terms* [i.e. they need to buy tickets].

Potential employers sometimes promise future rewards and status, often facilitating illegal earnings during working hours (by using facilities at one's job for personal goals, or accepting gifts and bribes). This phenomenon is well illustrated by the following well-known joke:

A policeman takes a job at his local Police Department. Six months later, he receives a phone call from his superior:
"Hey, Sergeant! How come you haven't come over to pick up your pay?"
"What? I had no idea you got paid for this job! I figured you get your gun, you get your badge, and after that you're on your own..."

Low-paying jobs, along with a plethora of opportunities for making easy money on the side, are a given in Russia. In 2007, the total number of government officials was around two million (not including those in law enforcement, the judiciary, and the revenue service). When law enforcement officials are included, the number doubles. Low-level bureaucrats officially earn anywhere from $200 to $500 a month. Many government officials live off bribes.

Another familiar Soviet joke states:

There are two kinds of people in Russia — those who pretend to work and those who pretend to pay them for working.

В ларьке
имеется в продаже
картофель

1 кг — 2000 руб

ТРЕБУЕТСЯ
ОДИН ТОЛКОВЫЙ
ПОМОЩНИК-ТРУДОголик
(РАБОТА ГОЛОВОЙ).
Оплата высокая
в/образование желательно

In this paternalistic society, many jobs do not constitute full-time
employment — they are part-time jobs that imply earnings on the side.
The pay is low, matching the job's requirements, and the level of
supervision over the employee. Employers never cease in their search
for their ideal worker, one who will continue to toil no matter what the
pay or working conditions are, because they have a compulsion to work
— in other words, a workaholic:

Wanted: a bright assistant, workaholic (working with your head).
High wages. Higher education is a plus. [1994]

Let's not focus too much on the *high wages* claim of this handwritten ad — it was stuck to a wall in the street at a time when the average monthly wage in Russia was less than $100. What is interesting here is the problem of motivation and labour across the country. In many provincial regions, people are not actually driven by high pay or other benefits. As in the big cities, the prime motivator is working 'for the good of the country':

New project!
Working for the advancement of Russian science
An invitation for profitable co-operation to all intelligent and highly educated people. Call 279-47-87, from 5 to 8 p.m.

All manner of ideological motivations are used:

Nursing is a profession,
Being a sister of mercy is a vocation.
Maybe it's the one for you.
The St. Dmitri Academy of Sisters of Mercy announces an extended
admission period for the daytime classes in the speciality General
Nurse Practitioner...

The wages for most jobs are so low that almost all commercial establishments have vacancy ads in their windows:

Wanted: A sales person for the store on Vavilova Street, Fersman
Street. Call 123-47-77, 128-93-58

These employment ads cannot be fully understood without some background information regarding the standard of living in Russia at the end of the 20th century. In 1992 the average monthly pension amounted to less than $1; in 1996 it was approximately $68; and at the end of 1998 just over $20. In 2005, the average pension in Russia reached the $100 mark. The highest pension level for the past twenty years. It is, however, an average pension. In reality, many pensioners still live well below the poverty line. One must also understand that a large slice of the urban dweller's pension must cover the utilities bill, which at the present time already exceeds $50 a month.

In 1992, the average monthly wage was $22; in 1996 it had risen to $154; but by the end of 1998 it was $62. In 2005 it had reached $302. Although improvement is evident, overall the situation remains grim. The minimum wage in 2005 — the most favorable year — was $30 a month, about a tenth of the average monthly wage, a proportion that has remained consistent over a number of years. One should also remember that people were paid very erratically, with delays sometimes lasting months. Moreover, between 1991 and 2000, people who had any savings lost them — this was a result of various financial crises, the plummeting value of the rouble, and other charms of shock therapy reforms, unofficial markets, and a raw materials economy. Today, around forty million Russians still live in relative poverty.

In this climate people advertising their services regularly charge paltry fees:

Will make video clips
B&W 16 mm film
B&W 8 mm
and VIDEO
$30. [1995]

On top of the ad, someone scrawled:

Give Stepaska a ring.

Needless to say, the quality of such services was as low as the cost. The paternalistic state also compensates people in the most astonishing ways, sometimes using encouragement of a symbolic nature, rather than money. The reward for labour might be a medal, but only as a result of a long bureaucratic procedure:

Attention: Unemployed veterans of the rearguard.[1] *To obtain your '50th Anniversary of the Victory in the Great Patriotic War' medal, you must submit your registration to...* [1995]

1. The term *rearguard* refers to people employed in military production plants during the Great Patriotic War (World War II).

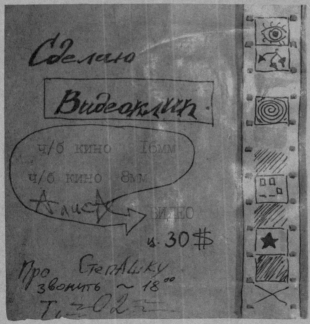

Unemployment has also contributed to the extremely low level of wages. According to the Bureau of Federal Statistics, the level of unemployment in recent years fluctuates between five and seven million people, this translates to about ten percent of the economically active population. This number doesn't include part time workers or those who earn less than what is considered to be a living wage, Russia counts at least several million of these.

To counterbalance the situation, government officials offer various kinds of 'social assistance' and 'extra earnings'. Election time is a particularly good season for earning some extra money:

For questions and remuneration for voting, visit the Administration of the Kirovsky District, office 14
Mon, Wed, Fri: 10 a.m. — 1 p.m.
Tue, Thu, Sat: 2 p.m. — 6 p.m.
Sun: 9 a.m. — 2 p.m.
Responsible parties..., Dept. of Social Welfare...,
Dept. of Consumers. [1996]

This was an especially cynical offer, since the 'remuneration' was paid out by a govenrment department (the Department of Social Welfare).

Swindlers of all shapes and sizes who lure gullible people with their murky schemes comprise yet another group of advertisers offering easy money. These ads are usually printed professionally. Among them are religious sects appealing to superstitious people, dubious characters trying to buy voters in an attempt to seek political power, and inevitably, scammers who set up pyramid schemes. Some of these pyramid schemes are even aimed at the victims of other pyramid schemes:

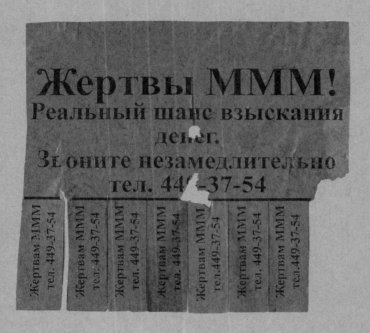

Victims of MMM! [MMM was a Russian pyramid scheme, which fleeced millions of people]
Here's a chance to get your money back!
Call now: 449-37-54 [1995]

The subject of working conditions requires special attention. This notice on a vendor's stand sums it up nicely:

If you need me, I'm keeping myself warm in the public toilet.

Here the employer's requirements of their personnel are perhaps overly inclusive:

A Russian commercial trade company needs a freight handler.
Requirements: strong male, 30 – 50 yrs.
DISABILITIES NO OBSTACLE.[2]

2. Courtesy of Mrs. Golovatykh, taken from a Novosibirsk bus stop.

In other cases, the only requirement is that the employee is not an alcoholic:

Wanted:
1. Recycled paper handler (no drunkards!) 200,000 rbls.
2. Experienced salesperson living in the area. [1996]

The search for people willing to work for next to nothing is often aimed at those who, for a variety of reasons, are unable to work:

Employment for mothers. We know it's tough for you now. You have to work and look after the kids at the same time. You can't split yourself in half, can you? We've found the solution! Call now to learn about it!

A similar handwritten ad is aimed at fathers:

Employment for fathers. Our kids can't even remember what we look like. We just keep on working and moonlighting, and it's still not enough, right? We've found the solution! Call now to learn about it! Work 101-57-37 [1996]

Some job offers are thinly veiled covers for extortion. In these cases, the ad promises a lucrative job which requires an initial monetary contribution from the employee. Any such requirement is a clear sign that the ad is a scam:

If you are a worker, a student,
A simple intellectual,
A doctor, a tailor, a banker,
Or even an athlete, a salesman, or an actor,
And you want to make some extra money,
We have work for you.
Don't forget to bring your money,
Your ID and your mailing address.
Call now and don't be shy,
And tell all your friends.
Work
295-10-73
8 to 11 p.m. [1995]

Finding work yourself, however 'intellectual' you may be, is a hopeless prospect unless you advertise your youth and appearance:

Ph. 931-27-40
Cathy
Artistic, attractive, smart girl (21 yrs. Moscow State University student) with strong organizational skills and successful two year career as a TV anchor and program director... of a regional broadcasting company is seeking a job.

PUBLIC TOILET SCRIBBLERS

Only queers piss here. If we catch you — you're fucked!

This chapter presents a sampling of toilet messages. Let me begin with a classic example of lavatory folklore:

Toilet scribbler,
You're so dumb.
Shit's smeared all over
Your mug and your bum.

This famous popular rhyme (which can take the form of both graffiti and a note) paints a portrait of a generic toilet poet. On the whole this culture is charged with both humour and creativity:

Caution! It has come to our attention that certain individuals have a habit of missing the toilet bowl while urinating. It is in our mutual interests that you treat such places with due respect. If you are inclined to put on airs, take a step forward. If you are absentminded, unbutton your fly — not your jacket, lest you soil your trousers. If you are short in stature, use a stool, rather than jumping up and spraying about. Finally, if you pee to one side, move over. Thanks in advance!

So people adhere to the basic rules of keeping toilets clean, instead of:

It's much shorter than it looks.

A phrase that is more to the point may be used:

Don't flatter yourself — come closer.

Against this backdrop of unsanitary grunge and grime, the request of a janitor to flush excrement sounds perfectly appropriate:

Fellow Pharaohs! Please flush your pyramids after you!!!

In office buildings, such notices may be written in the language of their occupants. Managers, for example:

Attention office staff! Please flush the toilet regardless of goals set and results achieved. The Management. If the results have exceeded all expectations, please use the toilet brush. Janitor.

Some janitors use a sharper tone:

Don't throw cigarette butts in the toilet bowl. Do I piss in your ashtray?!! Janitor.

To counteract careless habits, janitors may turn to threats as a last resort:

Honorable police, please don't throw tampons, sanitary napkins, and other intimate products along with newspapers in the toilet — or I'll lock it up and there will be no place for you to shit!

The struggle for a high level of culture in communal living often reaches boiling point:

Warning! Only queers piss here. If we catch you — you're fucked! Just you try!

Women are usually less brutal than men in their notices:

I never thought we had such PIGS living in our dorm. Guys visit all of us all the time, so please wipe off your monthly traces of the Red Army. By morning, the toilet and the lid should be sparkling clean! Didn't your mother teach you anything?!

The new Russian elite is not much different in this respect from other mere mortals:

Gentlemen bankers and entrepreneurs, an urgent request: please don't dump your used tea leaves and other things in the sink. Use the toilet bowl.[3]

Unconventional approaches can be very effective in a superstitious country. They are sometimes deployed in the battle to instill good bathroom habits:

This place is cursed. Soiling it will cause impotence and incurable diseases of the prostate gland. Anastasia the Witch.

Some notices also reveal strange customs of visitors to public toilets:

To visitors: We urgently request that you not wash your shoes in the sinks. The Management.

Another such notice prohibits the washing of hair and vegetables:

NOT ALLOWED: WASHING FEET, HAIR, FRUIT AND VEGETABLES IN SINKS!

3. From the collection of Artemy Lebedev.

A humorous cleaning lady hung the following notice on a toilet wall:

Don't take Little Willie for a swim in the sink!

And, finally, the acme of wisdom:

Dear customers, if you are not satisfied with the condition of our toilet, push down the handle to summon assistance.
The Management.

In other cases, there is no need to summon assistance, since all activities are monitored by a guard:

For your safety the toilet is under video surveillance.

Some notes also contain usage instructions:

The toilet rim is for your behind, not your feet.

Because archways, courtyards, lamp posts, and foyers of buildings are widely used for answering the call of nature in Russia, there is a genre of notices that warn against such activities. Profanities are commonplace:

Piss and we'll fine you.

As are threats:

Shit here again and you'll be wiping it up with your face!!!

Even appeals to a mythical sense of citizenship:

Neighbours, have some respect for each other. Quit pissing in the lift!

At the same time, the authors of these messages seem to consider themselves to be the guardians of morals and polite behaviour:

Quit messing in the lift, morons! Set your arse on fire with your lighter and spit there, too! The lift is meant for people. If you're a fucking animal, take a fucking walk! I'm fucking sick of this!

Finally, the most radical of all:

Morons! If I see you shitting I'll shoot!

The condition of the lavatory facilities themselves are broadly characterised by the following two notices found on toilet cisterns:

Pull the handle very gently, or it will be like yesterday
and:

Use the bucket to flush.

So, if you enter a Russian toilet, be prepared for the following situations: the cistern either works, but very poorly, or it simply does not work at all. The next example is relevant to both:

If you piss and take a dump,
Flush it down and clean your rump.
If your artwork just refuses,
Kick it down and leave some bruises.

A public toilet falls within the sphere of public services. This message comments on the quality of these services:

Toilet
Open from 8.00 a.m. to 11.00 p.m.
Free admission
Paid services.

It's a little unclear exactly what kind of services the place offers. The question isn't too hard to answer — it sells toilet paper — which is otherwise absent from the cubicles, and the privilege of using soap.

Fliers advertising a contest for the best instructions on how to use toilet paper have been found tucked into toilet paper rolls across St. Petersburg:

Instructions for Use.
1. The product is useful in many areas: Leningrad, Moscow, Novgorod, and others. For best results, use this product in your permanent dwelling place.
2. Remove the roll from the holder, and place it at chest level in a horizontal position.
3. Perform act of defecation.
4. Make sure the act is complete and you feel no further movement of the bowels (this is important for economising on the product and preserving natural resources).
5. Grasp the end of the product with your right hand in a smooth transitional motion...[4]

Public toilets themselves are full of rhymes that parody straightforward instructions for using it:

Comrades and proles,
Don't shit on the rim.
Look! There's a hole
For keeping shit in.
— The Management

Such rhymes circulate as urban folklore for decades with many versions.

Finally, the following text embraces the topic of immorality and ignorance and inescapable punishment for these sins in graphic and categorical language:

It is not just immoral to stand on the toilet bowl with your feet (you could use some toilet paper); it is very dangerous! There have been numerous occasions when feet have slipped — and broken, dirty tiles can cut your arse like butter. A gruesome death from lock-jaw is not worth the price of your ignorance.

4. Found by L. Samoilov and V. Vasyutinsky.

BUYING, SELLING, BARTERING
Will trade power planer for property voucher.

The authors and readers of these street advertisements are very diverse. For the most part they consist of those who are barely able to scrape a living, they are striving for a better lot in life, perhaps by starting up their own small business. In this context, the very notion of business becomes radically redefined:

Fellow tenants, don't leave packets of old newspapers next to the building; take them to the bins. Maria Andreevna doesn't do newspapers anymore; she has another business. [2001]

Collecting paper and old rags for recycling also qualifies as business:

Will take old rags and paper bound in packets for recycling. [1996]

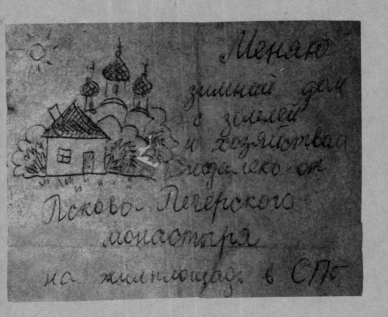

In official terms, businesses in Russia fall into four distinct groups: large-scale, medium-large, middle-sized, or small. In reality, there are no middle-sized or small businesses. They are either super-large or super-small. The ad cited above is an explicit example of the latter. Super-small businesses are often run by naïve and inexperienced people who have not been able to find a place for themselves in the New Russia, with its plethora of informal markets, collapsing infrastructure, and merging of business and government bureaucracy. Through home-made ads people can sell old junk or barter it for other completely incongruous or incommensurable items:

Will trade old broken watches from the Soviet era for socks or honey...

These attempts to sell unusual items in even more unusual places look quite normal in the context of the country's widespread poverty, where half the population survives only on meagre, unofficial earnings.

In the absence of a true market infrastructure for property, people even trade houses and apartments:

Will trade a winter house with land and outbuildings in the vicinity of the Pskov-Pechera Monastery for premises in St. Petersburg.

Rental arrangements can also be taken care of:

Wanted to rent: a room in Petrogradsky or Primorsky District for single person.

Some people sell things that don't belong to them at all. This story (about the philosopher Alexander Piatigorsky, recounted to me by one of his students) shows how even the most educated can be duped by a convincing sign:

One New Year's Eve Piatigorsky went to buy a Christmas tree. It was late, and most places were already closed or had sold out. Suddenly, he saw a sign saying 'Christmas Trees'. A man was standing on the street holding a Christmas tree in his hand.
'How much for the tree?' Piatigorsky asks him.
'Five roubles,' the man replies.
As soon as Piatigorsky pays him, the man grabs the money, lets go of the tree, and quickly runs off. Piatigorsky, slightly taken aback, reaches out to grab the tree, but it won't budge — it's literally rooted to the ground.

Other people make notices to remind customers that they don't want to buy or sell anything:

In this apartment we don't sell moonshine, buy fish, or know the whereabouts of granny Ann! Now clear off!

Money is not always paramount. The author of this ad seeks to barter vouchers in exchange for tools or clothing.

Will sell or trade for property voucher:
1. Two electric sanders and power planers
2. Second-hand fur coat, size XL-XXL
3. Women's faux fur coat, size XL
4. Women's coat with mink collar, size XL
329-04-71 [1993]

СНИМУ !
КОМНАТУ
В ПЕТРОГРАДСКОМ
или В ПРИМОРСКОМ
Р-ОНАХ
ДЛЯ ОДНОГО
ЧЕЛОВЕКА

Продаю или меняю на **ВАУЧЕР:**

. Две шлифмашинки и эл. рубанок

. Полушубок б/у 50÷52р

. Шуба ...ская искуственная 48÷50р

. Паль... ...ское, воротник-норка 48÷50р

320-04-71

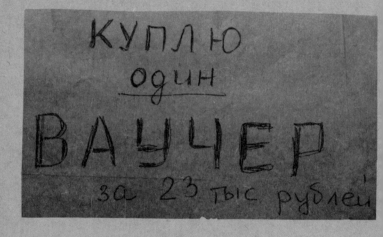

On 1st October 1992, every citizen of Russia received a share of government property — a voucher worth 10,000 roubles, which one could invest in companies undergoing privatization. Post-perestroika, the voucher was the first stable form of security in Russia.

The assumption was that a sizable class of property owners would be created, who would form the core of the new middle class in the country. There was widespread confusion about what to do with the vouchers. Some traded them for a bottle of vodka, others for an apartment in Moscow. Soon, various commercial banks, well-off individuals, and the mafia, started to purchase them at inflated prices:

Will buy one voucher for 23,000 roubles.

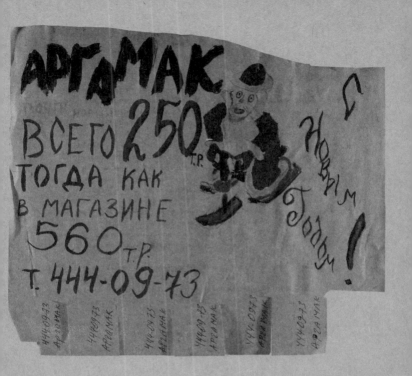

The majority of people did not benefit from their vouchers, nor did they become prosperous property owners. Initially, selling a single voucher could buy a couple of four-and-a-half ton ZIL dump trucks. Eventually, however, the voucher had devalued so drastically that it was only worth the price of two kilos of smoked sausage. The following crude dictum, expresses the attitude of the average Russian to the now virtually worthless vouchers:

Take your voucher, roll it up, and stick it up your arse. No, this doesn't mean you're queer.[5]

The government's hope that privatization would result in profits also went unrealized. Of 250,000 companies, only about 47,000 went private. While the government gained over 150 million roubles from privatization, it failed to fulfill its main goal — economic stability.

Due to widespread poverty the sale of used goods became a firmly rooted practice:

Argamak snowmobile, like new, for just 250,000 roubles (goes for 560,000 in stores). Phone: 444-09-73. Happy New Year!

5. Josef Raskin, *Encyclopedia of a Bullying Orthodox Jew*, Moscow: Knizhny Klub 36.6, 2005.

People sell all manner of things to make an extra rouble, from old Soviet-era bicycles:

Orlionok bike. Lowest price for a quick sale!

or:

Arc welders 598-75-04

to livestock:

A three-month-old piglet and a milk goat. Visit 29/1 Koriernaya St.

The mix of products can be quite incongruous too:

For sale
Vodka — 850
Eskimo ice cream — 200

or even:

Milk, cottage cheese, cement —> 50 meters.

Elsewhere laundry detergent is sold alongside stockings:

Laundry detergent. Unique cleaning action. Gets rid of any spots.
Scrubs for you! Bio-Henko — 4,000 roubles.
Stockings, size 44–60, reinforced toe from Byelorussia.
Long lasting and stretchy.
Warm men's jackets. We sell cheap. Large sizes.

And, finally, the most inexplicable juxtaposition of all:

1. Paper for sale
2. Will hire trolleybus
272-60-04

...ёнок поросёнок,
...за и дойная коза
...тесь на улицу
...но дом 29/1.

ПРОДАЁМ
ВОДКА-850
ЭСКИМО-200

1. ПРОДАЮ БУМАГУ

2. СНИМУ Троллейбус

...-600

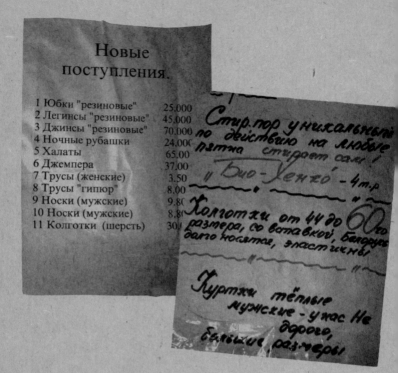

Ads like this seem quaint to us now. They were only possible in the 1990s, when the market infrastructure had not yet fully formed and people's notions of advertising were still rudimentary, lacking the sophistication of their western counterparts. Hybrid advertisements developed, resembling something between a shop sign and a price list:

New!
1. *'Stretch' skirts 25,000 rbls.*
2. *'Stretch' leggings 45,000 rbls.*
3. *'Stretch' jeans 70,000 rbls.*
4. *Nightgowns 24,000 rbls.*
5. *Robes 65,000 rbls.*
6. *Sweaters 37,000 rbls.*
7. *Underwear (women's) 3,500 rbls.*
8. *Guipure underwear 8,000 rbls.*
9. *Socks (men's) 9,800 rbls.*
10. *Socks (men's) 8,800 rbls.*
11. *Stockings (wool) 30,000 rbls.*

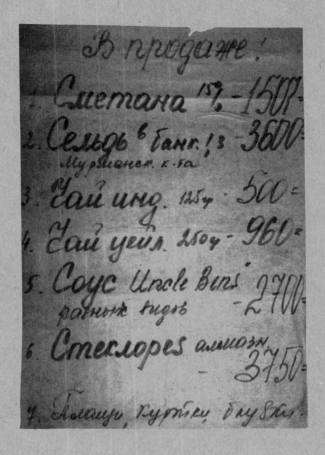

Another popular form was the advertisement-cum-price tag which comprised a list of goods posted at the entrance of the store:

For sale
1. *Sour cream 15% 1,507 rbls.*
2. *Canned herring from Murmansk 3,600 rbls.*
3. *Indian tea, 125 g. 500 rbls.*
4. *Ceylon tea, 250 g. 960 rbls.*
5. *Uncle Ben's spaghetti sauce, different flavours 2,700 rbls.*
6. *Diamond glass cutter 3,750 rbls.*
7. *Coats, jackets, blouses.*

Shops would sell any goods they had, so listing *Uncle Ben's spaghetti sauce* alongside a *Diamond glass cutter* was not so unusual.

КОНФЕТЫ С
ЛИКЕРОМ (ПРИБАЛТИКА)
ЖЕВАТЕЛЬНАЯ
 РЕЗИНКА
 ЧУПА-ЧУПС
ПЕЧЕНЬЕ
ТУШЕНКА
ФАСОЛЬ
МАСЛО
КУКУРУЗА нет

Nowadays, black caviar is readily available in any Moscow supermarket, though it costs around $800 a pound. Thanks to the well-oiled mechanisms of the black market, it is also possible to buy it under the counter in any large-scale Moscow produce market. After a brief conversation with the right salesperson, you'll end up shelling out just $250 a pound. In Astrakhan, the very same jar would go for only $80 a pound. Even if you factor in all the shipping costs, the only thing that can possibly account for the nine hundred percent markup are the bribes required to turn the wheels of commerce.

Another characteristic of ads from the 1990s was the use of terms that in retrospect appear slightly bizarre, such as *'assortment for children'*:

We carry:
Baby soap
Misc. soap
Laundry detergent
Toothpaste
Black dye
Assortment for children
Clothing
Alcoholic beverages
Beer
Cigarettes
Soft drinks

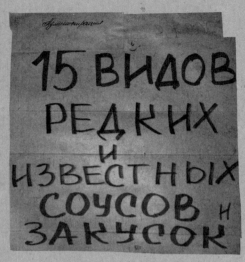

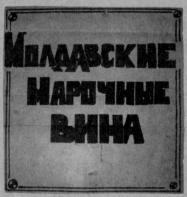

Assortments, or product ranges, were rather paltry; but in Russia during this period even fifteen sauces was an unheard of luxury:

Fifteen rare and famous sauces and treats.

A motley sign on a small piece of paper was meant to entice passersby to stop and purchase:

Fine Moldavian Wines.

Occasionally obscene language crops up. It can be found even in ads for ordinary wares in an attempt to ward off annoying questions from inquisitive customers:

Other than what you see on display, we've got fuck all!

ОБЪЯВЛЕНИЕ.

МАГАЗИН ПРИНИМАЕТ НА
РЕАЛИЗАЦИЮ (КОМИССИЮ) ПРОМЫШ-
ЛЕННЫЕ, ХОЗЯЙСТВЕННЫЕ,
ЭЛЕКТРОБЫТОВЫЕ ТОВАРЫ, А ТАКЖЕ
ПРОДУКТЫ ПИТАНИЯ (ВОЗМОЖЕН
НАЛИЧНЫЙ РАСЧЕТ)ЗА ПРОДУКТЫ
ПИТАНИЯ.)

The tone of this notice leaves no doubt about the quality of service and manners of the sales personnel.

In a fit of unrestrained sincerity, someone may post an ad that contains personal information:

Price: 1,500-2,000-2,200. Liquidation sale!
I'm going back to Vietnam for good. Ban Fong.

The quality of goods found at ad hoc or informal markets is evident from the following text:

Announcement. Commission shop[6] accepts industrial and household wares, electrical appliances, and food products (for cash) in exchange for food products.

Commission shops buying food products from random people on the street was another black market enterprise. This practice formed as a result of bureaucratic obstructions and bans on private commercial initiative:

Illegal trade by private individuals prohibited! 2,000 rouble (and higher) fine![7]

6. Commission shops helped people sell second-hand items for a commission fee. Individual policies differed, but most stores only paid after the submitted item had been sold.
7. From the collection of Artemy Lebedev.

Informal markets often sold goods that had lost their pristine appearance at lower prices:

Only here! And just for YOU! Damaged ice cream at half the price!

Here low quality and even lower prices find the perfect location:

Vietnamese market has relocated behind the toilet. Low, low prices, as usual.[8]

Ad hoc market locations can be quite incongruous:

Attention! ~~Chicken~~ young fowl will be sold on 26th June at 8:40 a.m. near the church. Please don't be late, and wait for us!

The exhortations *don't be late* and *wait for us*, appearing in the same sentence, are only possible in the universe of makeshift markets.

Want ads can be simultaneously idiosyncratic and specific:

Will buy. 'Humpback' in good condition. Phone...

Humpback, in popular parlance, is the ZAZ-965 microcar.

Even good runners have their drawbacks:

For sale. Ural motorcycle. RUNS. No wheels.[9]

Some ads are, in effect, thinly disguised diatribes on the part of merchants towards their customers:

No vodka sold from 11 p.m. to 8 a.m. And stop cursing and shouting! Don't even ask! We're all in this together.

The mysteries of customer service lurk behind:

Dear customers: In the hot snack section we only serve draft beer. The Management.

Even Russians are left puzzled about what a hot snack section is. However, if you still insist on ordering a hearty meal, dubious hot dogs and round-the-clock soft drinks on tap are there for the asking:

Doughnuts, hot dogs, coffee, tea, and soft drinks on tap 24/7. 10 meters

Here is another example of an announcement from a cafeteria which amply illustrates the concept of customer service:

Announcement. Dear public, so you don't complain, we would like to warn you beforehand that the meatballs are from the day before yesterday. Kitchen Manager.[10]

8. Found in the Central Market, Perm, by Y. Belikov.
9. Found on a lamp post in Saratov by O. Polstianova.
10. From the collection of V. Karpusha.

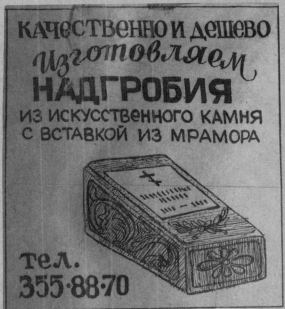

The following warning is also rather unnerving:

Dear passengers, to avoid food poisoning from outdoor stalls, we recommend that you buy meat dishes in cafeterias that refrigerate their food. The Management.

In the event that any case of food poisoning was fatal, the following ad would come in handy:

Quality and inexpensive gravestones from artificial rock with marble inlay. Phone 355-88-70

Artificial rock is probably a euphemism for a concrete slab.

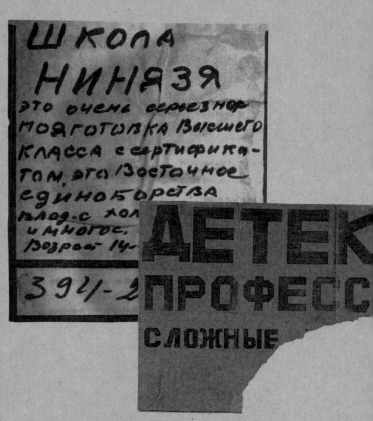

Like every other commercial sphere, education in Russia advertises a most improbable range of 'services':

Ninja School offers very serious training of the highest calibre, with certificate. Martial arts, cold weapons, and much, much [more]
Ages: 14 – 40
Any sex
Call 394-22-48 before 12 a.m.

It appears that Sherlock Holmes has been deputised to recruit budding spies in the following ad:

Mafia DEVELOPMENT gibberish center for intelligence agents recruiting for preparation stage. SPY SCHOOL.

Early training of citizens in the correct notions of love for the Motherland is essential. Experts who have already graduated from spy school are ready to sell their services:

Professional Detective

47

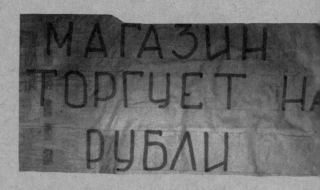

Recruiting in the sphere of education doesn't leave a shadow of doubt as to how the system works:

To graduate students, teachers, or just smart people: help urgently needed in the area of mid-19th century Russian literature.
Payment in roubles or other currencies.

Ready-made high school and college diplomas are sold on every street corner. As for 'other currencies,' the main currency for private savings is still the dollar. In the 1990s, the dollar was freely accepted in many commercial establishments. It was only later that signs appeared saying:

This store accepts roubles only.

Rhymes are not uncommon in advertisements. The following, written on a piece of cardboard with a simple ball-point pen, is a unique example of the genre:

Don't trust Zhuguli and Baltika beer,
You'll get the biggest kick from Tver.
You won't find a better brew
In all St. Petersburg, it's true —
We'll open the bottle and serve it to you.
C'mon, pals, don't be down in the mouth,
Tver beer's the best in the north or the south.
And so that life is full of cheer,
Hurry, hurry, drink your beer!
To set your girlfriend's mind at ease,
Pour her another of these, please.
If you want him to whisper sweet nothings in your ear,
Pour him another pint o' beer, dear!
Come inside, wipe off your frown,
Order a Tver, and drink it down.

ЖИГУЛЯМ И БАЛТИКЕ НЕ ВЕРЬ
ВЕДЬ САМЫЙ КАЙФ ТАК ЭТО ТВЕРЬ
ХОТЬ ВЕСЬ ПИТЕР ОБОЙДЕШЬ
ЛУЧШЕ ПИВА НЕ НАЙДЕШЬ
ЗДЕСЬ ОТКРОЮТ И НАЛЬЮТ
И БУТЫЛКУ ПОДАДУТ

ЧТОБЫ НЕ БЫЛО ТОСКЛИВО
НАДО, БРАТЦЫ ВЫПИТЬ ПИВО
И ЧТОБЫ ПО ЖИЗНИ ИДТИ ВЕСЕЛЕЙ
НАДО ПИВКА ПОПИТЬ ПОСКОРЕЙ

ЧТОБ ПОДРУГА НЕ ВОРЧАЛА
ТЫ НАЛЕЙ ПИВКА СНАЧАЛА
ЧТОБЫ ОН ЗАВОРКОВАЛ
ВЫ ЕМУ ПИВКА В БОКАЛ
ПОДХОДИТЕ ПОДЛЕТАЙТЕ
И ТВЕРСКОЕ ПОКУПАЙТЕ

СТИХОТВОРНЫЙ ДАР
...МИРУЮ ТОВАР

Rhyming is also a means of earning money, which is evident from this peculiar advertisement on a tiny scrap of paper:

My tongue works in rhyming pairs
I'll make the ad to sell your wares.

**СТИХИ К ДНЮ РОЖДЕ
НИЯ — ЛУЧШИЙ ПОДА
РОК И ПРИЯТНЫЙ СЮ
ПРИЗ**

Сочиняю дружеские и шу
ливые поздравления в сти
хах по любому поводу (д
рождения, свадьба, юбиле
проводы на пенсию, праз
ники и т.п.). Строго индив
дуальный и гибкий подхо
с учётом всех нюансов — ос
бых привычек, оригиналь
ных манер, специфики
характере и поведении
т.д. Срочное исполнение
минимальные расценк

440·40·26 440·40·26 440·40·

Writing rhymed verse for anniversaries and holidays is quite common in Russia. Naturally, rhymes are sold for 'low, low prices':

A birthday poem is the best present and a nice surprise.

I write friendly and funny greetings in verse for any occasion (birthdays, weddings, anniversaries, retirement parties, holidays, etc.). Individual and flexible approach, sensitive to all nuances — habits, mannerisms, character traits, temperament, and so forth. Rush orders at low, low prices. 440-40-26.

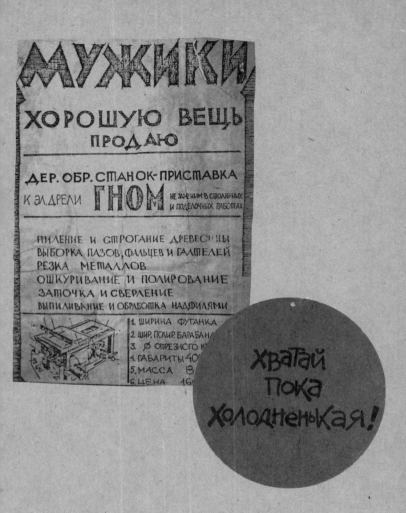

The familiar tone (like the *pals* in the beer ad) is characteristic of many sales ads:

Hey, guys! Check this out: selling woodworking attachment for the Gnome electric drill. Indispensable for joiners and craftsmen...

This familiarity is often expressed in an intentionally relaxed and colloquial style:

Get 'em fresh from the fridge!

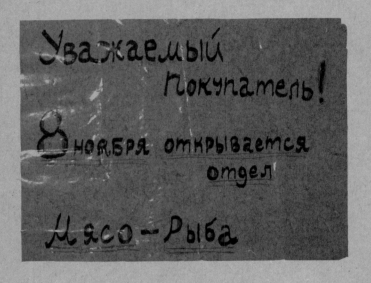

The picture would not be complete without the following classic ad from a grocery store:

We are out of everything (and we mean everything!) Don't even ask.

Here is another detail to round out the economic picture of our vast Motherland — an ad for something that isn't. A note posted on an empty shelf of a store read:

Vodka coming soon.

Sometimes, the hungry citizens of Russia did see ads in stores that gladdened their eyes and stomachs:

Dear customers,
On 8th November we're opening a Meat and Fish department.

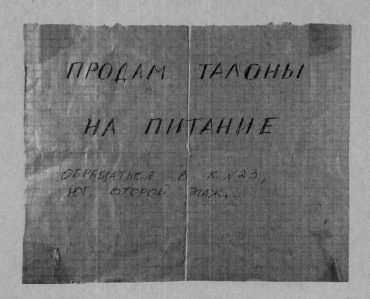

The state of the Russian economy during the 1990s was eloquently expressed here:

Will sell ration cards. Apt. 23, south, second floor.

However, even with ration cards it was not always possible to buy the most basic necessities:

9th April. We're out of rationed goods. Sorry. The Management.

Another class of ads makes dubious promises to restore lost happiness to the customer:

A must!
Buy weights for legs, hands, and abdomen, and change your life!

Fighters and martial artists.
Weights will give you a stronger punch and kick. Your speed will increase and you'll move so fast you'll be invisible. They'll never know what hit 'em!

Women
Of course, aerobics and walking with weights on your ankles will give you a slender and attractive shape. All your life your beautiful legs and hips will bring aesthetic pleasure to the men you know and love... And even men you don't know... Heads will turn and all of St. Petersburg will watch admiringly as you pass by...

Achieving happiness and beauty needn't mean a trip to the hospital:

Women! Straighten crooked legs without surgery.

The most popular kind of ads concern miraculous weight loss:

Want to surprise everyone? Lose up to 15 kg. in just a month.

These were mostly ads for Herbalife-esque products, disguised in this case as Thermojectics. Vulnerable customers eagerly ingested what was essentially an extract of Garcinia Cambodia, with a little bit of chromium and riboflavin. A small bottle of 60 tablets cost $26 — the cost of 100 tablets of a real multivitamin complex containing sixty ingredients (including chromium and riboflavin). The main attraction of these products, however, is not the contents, but the miracles they sell:

Lose weight with Thermojetics once and for all!
447-71-38 Lena
414-98-77 Tatiana

The results I got with Thermojetics were unbelievable! I lost 70 kg.
and I haven't gained it back. And I feel great!
— Victor Vykhodtsev

With Thermojetics I lost 45 kg. and went down nine sizes.
I feel fantastic and I've stayed this way for two years!
— Nancy Brown

You can do it too! Call now: 419-37-66 Irina
Approved by the Ministry of Health.

The most extreme examples of ads promising peace of mind and physical beauty recall fairy tales or myths, with heroes that cast off the shackles of age or vulnerability:

The health of the nation is at stake!

Are you a stooped over young man? Do you want to become a slender, gallant knight, to be an Olympic champion in boxing, karate, light athletics, soccer, volleyball, hockey, gymnastics, etc.?

Are you an old man? Do you want to turn into a slim man with the gaze of an eagle? One who leaves behind his aches and pains, steps lively again, and who enjoys the glances of pretty girls?

Are you a would-be charmer, whose legs every Petersburg man will caress with his glances?
Call now, at 464-76-91, to buy 3.5 kg. weights for legs, 1.7 kg. weights for arms, and 10 kg. weights for the abdomen.

Many ads offer effective remedies for balding and ways of restoring hair on scalps:

Losing your hair? Your head look like a billiard ball? Don't despair. Visit Valentina Medical Center. We can help. Call 555-50-95.

S. S-y, 20 – 21 yrs. 1st degree seborrheic alopecia. Duration of illness two years. After seven months of treatment with Silocast.

L. T-va. Subtotal baldness. Duration of illness four months. After twelve months of treatment with Silocast.

And to become completely healthy, attractive, and charismatic, you need to clean your system regularly:

You clean up your house once a week. When was the last time you cleaned out your body?

Sometimes, recipes for happiness are aimed at people who have given up any hope of ridding themselves of ailments. The 'help' that these ads offer sounds truly fantastic:

Bacchanalia is
— letting out your innermost emotions and passions;
— letting go of your inhibitions;
— a specially created environment, in which you do ONLY what you really want to do.
All this in an atmosphere of emotional safety and security on the banks of a river deep in the woods. [1996]

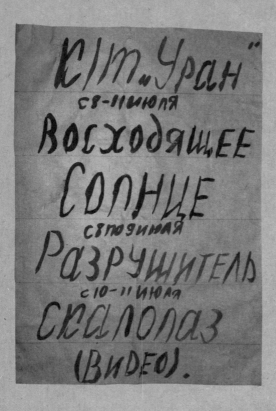

Announcements about film screenings form a unique category. During perestroika, they looked nothing like regular film posters. They were often handwritten one-offs, just a few centimeters in size. The quality of the movies was usually below all imaginable standards, as they were shown on ordinary video recorders attached to television sets:

Uranus Movie Theatre
8 — 11 July
Rising Sun
8 — 9 July
Demolition Man
10 — 11 July
Cliffhanger
(video).

This ad from 1994, the acme of modesty, contrasted completely with the Western billboard posters advertising the same blockbusters.

LOST AND FOUND

Please help us find an old lady!

Pasted among the many ads offering secrets to happiness, notices seeking to recover something valuable and dear to the owner stand out. They feature every kind of lost object, and occasionally even lost people:

Help! Our only son is missing...

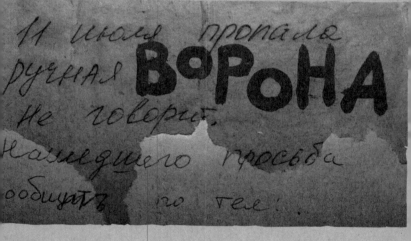

The people behind them yearn to restore a vanished past, to acquire the inaccessible, to dream the impossible... Russian cities, papered over with such notices, are shrines to lost relatives and missing items:

If you have found a little doll, please call us.
Mashenka's very upset about it.

Thousands of elegies for lost objects, dogs, cats, children, parents, and even crows resound through these ads:

Crow missing. Tame. Doesn't talk. If you find it, please call... [1995]

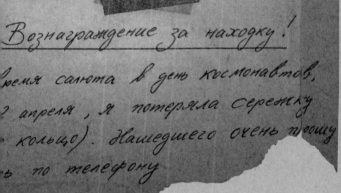

The missing flock also includes more exotic birds:

Lost, cockatiel. Nymphicus hollandicus. Grey, male.

The ads can be very optimistic:

*Reward! During the fireworks on the Day of the Cosmonauts',
12th April, I lost an earring (gold hoop).
If you find it, please, please, please call...*

In this world, lonely dogs wander around looking for vanished happiness,
just like people:

*A stray dog (male) has been spotted near Pulkovo Highway
(Pulkovets Club). White, fluffy, about the size of a large poodle,
clipped tail. He trails behind everyone, looking for his owner. [1994]*

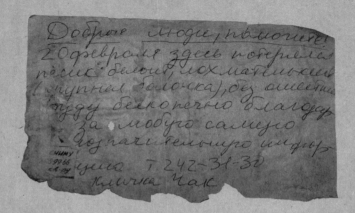

Forlorn owners search for their missing pets:

Good people! Help! On 20th February, I lost my little doggie on this spot. White, shaggy (large lapdog), no collar. I will be eternally grateful for the slightest hint of his whereabouts. Call 242-31-30. Answers to the name 'Chuck'.

There are two kinds of souls that inhabit this world — Those that are lost and those trying to find them:

On the 30th October, a man snatched an old Doberman from school. Smallish, black. Sick, needs medication. Please return him... [1994]

Just like people, animals are perfectly capable of upping and leaving:

Kind people! Please help me find my doggie! Black, smallish, with a white ruff, white paws, white tip on tail. Answers to the name 'Phil'. Left home on Friday, 9th August, headed towards Mozhaisk... [1999]

Some of these lost souls have become temporally disoriented and wandered off:

Lost: old lady. Left home and didn't return. Small, hunchbacked. Wearing: blue dress, red wool sweater, white kerchief with red flowers on her head, grey bedroom slippers. Memory gone. (Alzheimer's).

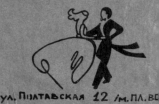

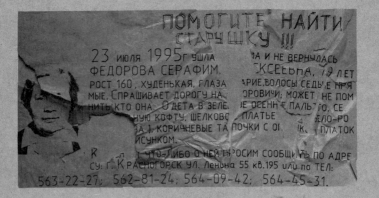

Others appear to know exactly where they want to go:

Please help us find an old lady! On 23rd June 1995, Serafima Fedorova left home and never returned. 79 yrs., height: 5'3", skinny, brown eyes, straight grey hair. Wants to find the way to Borovichi. May not remember who she is. Wearing: green winter coat, grey sweater, silk dress, brown slippers, and patterned kerchief. If you have any information regarding her whereabouts, please contact us at Krasnogorsk, 55 Lenin St., apt. 195 or call 563-22-27

These tragic figures have lost touch with reality, inhabiting a mythical past, longing for a utopian future. They live in bygone days, in their own private *Borovichi*.

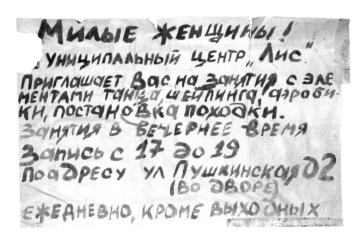

It would seem that Russians sometimes lose the most peculiar things:

Lost: JAWS. Ask at the seeds. Cafeteria.[11]

Here, *ask at the seeds* presumably means 'ask the vendor at the seeds and nuts stand.'

Some lost objects are very valuable:

On 1st January 2004, between 23.30 and 24.00, a Kalashnikov assault rifle was lost... If you find it, please report to the MP's office... Or any police officer... Anonymity and reward guaranteed.

A similar notice was seen at the Defence Ministry offices:

If you have found a handgun, please call. . .

Searching for lost firearms is not the only pastime of the Department of Internal Affairs. They also teach ballroom dancing:

The Police Department Palace of Culture invites you and your children to our modern ballroom dancing school at 12 Poltavskaya St., Vosstaniya Sq. metro.

But, then again, every palace of culture, club, or municipal centre in Russia has a dancing school. Passing the time is really not a problem here:

Dear ladies!
The Lis Municipal Centre
would like to invite you to lessons in the elements of dance, exercise, aerobics, and posture.
Classes held in the evening.
Register from 5 to 7 p.m.
Address: 2 Pushkinskaya St. (in the courtyard)
Every day, except weekends. [1994]

11. Found on the cafeteria doors of the Muromsk Plywood Manufacturers by O. Maslennikova.

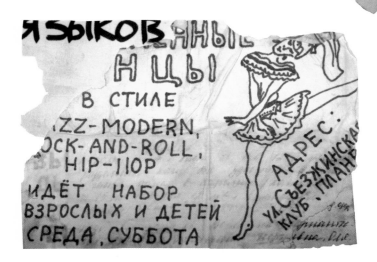

Citizens, if they so desire, can master many styles of dance:

Contemporary jazz and modern dance, rock 'n' roll, and hip-hop.
For children and adults
Wednesday, Saturday
Address: Siezzhinskaya St, Planeta Club. [2002]

This club for teenagers, located in the Petrogradsky District of St. Petersburg still exists, bringing dance culture to the masses.

The following ad, which contains profanities, shows a different aspect of human relationships — when the author doesn't care if he finds the person at all:

Lost: fuckwit. Answers to the name Theo. Height: a meter and
a dog's dick. Eyes: bloodshot. If you find him, kick his arse!

This seemingly optimistic notice is in fact addressed to no one:

I'm always with you! [1999]

It is as if the author is trying to convince himself that he is not completely lost in the void. The theme of total isolation is appropriate in a country where millions of lonely people feel abandoned by the once protective state: pensioners, the hard of hearing, the visually impaired, and those who simply have no means of survival.

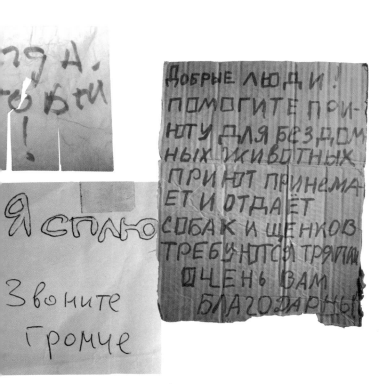

The following notice is particularly poignant:

Bang on the wall — I'm hard of hearing. [1995]

It was posted by an elderly woman on her apartment door in St. Petersburg. She didn't own a hearing aid — she could hardly afford to feed herself or buy clothing. These people lack any kind of social assistance or welfare, their pensions barely cover the utility bills. They have lost everything and live in a world of disillusionment and uncertainty. Sleep is a chance to escape the dismal reality:

I'm asleep. Ring louder.

In this realm of lost children and old people, the lot of animals is equally grim:

Good people! Help our shelter for stray animals. We take in and give away dogs and puppies. We need rags very much. Thanks!

ДРЕССИРОВКА СОБАК
КУРС ПОСЛУШАНИЯ
ВЫРАБОТКА ЗЛОБЫ

The conditions that these abandoned creatures live in are abysmal:

*Good Christians! Help five puppies living in the burned out stable,
in the apple orchard. The puppies are one month old, they are very
sweet and plump — so far. But winter's coming! What will happen
to them? Their mother is a mongrel but she's very pretty
and affectionate (she's no bigger than a sled dog).
Rescue them or call 144-43-98.*

Dogs, like people, are looking for a better life:

*Good people! Help!
A one-year-old precious lapdog is looking for an owner and friend.
The dog was rescued after a car crash and nursed back to health.
If you want to bring the warmth of a grateful and loving animal to
your home, call 247-04-17 or 513-72-73.*

The following ad illustrates yet another kind of super-small business in
Russia — the buying and selling of pets:

*American Staffordshire Terrier pups.
Mother and father are pet show prize winners. Moscow breed.*

Even pets with pedigree dream of finding an owner:

*Kittens, British Shorthair, black with complete pedigree of foreign
descent. Call 242-04-17*

When hazards await you around every street corner, a good guard dog
is a must:

Dog trainer. Obedience and ferocity lessons.

КОТЯТА

ПОРОДА
БРИТАНСКАЯ
ОКРАС ЧЁРНЫЙ
С ПОЛНОЙ РОДОСЛОВНОЙ
от иностранных родителей

242-04-17

Щенки
АМЕРИКАНСКОГО
СТАФФ. ТЕРЬЕРА.

Мать, отец - призёры виста-
вок. Московское разведение-
п...

Лучшая охрана ...

Т 279-12-20

The dilapidated Russian infrastructure is a rich source for all manner of warning notices:

Attention! The lifts are old and might get stuck. Don't get in with more than four people, because if you get stuck you'll suffocate.

The danger of drowning is as real as the probability of suffocation:

Dear residents. In the event of water leaks and floods from the heating pipes on the night of 30th July 1998, please notify the watchman of Belsk Riverboat Company. The Management. °

Jokes about the old and damaged waste disposal system abound. This sign was found on the pipes of just such a system:

We leak what you piss! (Pipes). [12]

At first, these notices suggest a fantastic, dystopian reality where time stands still. Power cuts can last for hours at a time:

Dear residents,
On 5th June 2006, from 9 a.m. to 4 p.m., the electricity in the building will be turned off for repairs. We are sorry for this temporary inconvenience. The Management

The hot water can be turned off just as easily too:

I have been informed that the hot water will be cut off for 30 days starting 6th May. Floor Chief.

Some use these cuts as an opportunity to supplement their income, selling goods targeted at the difficulties brought on by the situation:

Dear residents,
Due to the onset of summer, the hot water supply in your building will be turned off from May through to October. We apologize in advance. Utilities Service of the Building Management.
P.S. Sunlight washing-up liquid will help you solve some of your problems! Its unique grease-cutting formula is effective even in cold water. [13]

A similar announcement provoked a reaction from one tenant:

Dear residents, On 6th September 2005, from 9 a.m. to 5 p.m., the hot water will be turned off in your building. Please accept our apologies for this temporary inconvenience.

The following was added with a pen:

No! Apologies rejected!

12. Another variation of this popular message reads: *Let's take a leak together!*
13. Found in Rostov-on-Don by Alexander Volchkov.

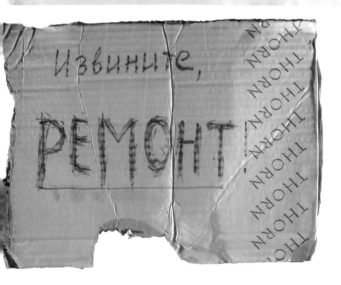

Apologies sound particularly ludicrous when traffic is disrupted by a network of excavation ditches criss-crossing busy streets and thoroughfares:

Caution! We apologise for the inconveniences caused by the laying of a heat-supply bypass. Please use alternative routes.

Sometimes these notices are particularly laconic — they can be made on a piece of cardboard with an ordinary marker pen:

Sorry, MAINTENANCE WORK!

Or, a work of art executed in large, crooked blue letters with a paintbrush on paper, the beautifully concise:

MAINTENANCE

ХЛЕБ

ДВОРА

В ПРОДАЖЕ

САХАРНЫЙ ПЕСО

по 53 РУБЛЕЙ

РЕМОНТ

СРОЧНО ТРЕБУЕТСЯ

ХОРОШИЙ БАРАБАНЩИК

I723516 КИРИЛЛ

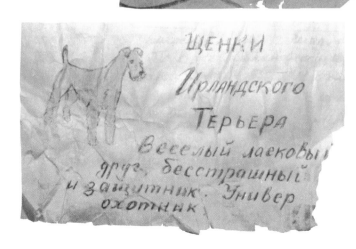

ЩЕНКИ
Ирляндского
Терьера
Веселый ласковый
друг, бесстрашный
и защитник. Универ
охотник

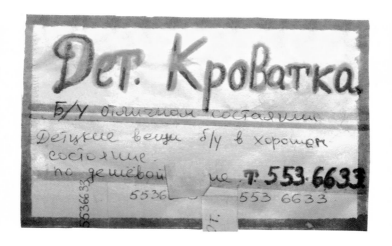

Announcements made by public servants in which they complain about the hardships of their jobs, their shortcomings and failures, give us an amusing insight into their peculiar world:

Attention residents!
In compliance with a decree from the Municipal Government of the city of Moscow, beginning in April of this year bills for heating and hot water services will be generated by UIAC (United Information and Accounting Centre) and put in your mailboxes. Payment stubs will no longer be used! We haven't received bills for April yet, and the bills for May and June only came on 20–22 July. Technically, the bills should arrive at the beginning of their respective payment periods. The system still has some kinks in it — bills may be made out to the wrong name, which may lead to confusion if you are on a subsidized payment plan, or you may suddenly 'inherit' someone else's delinquency record. Problems will arise for those who pay using their payment stubs or pay 3–12 months ahead. Now they will have to take a ride to pick up their bills in person. Please address all questions to the UIAC accounting office. Ph.: 34-19-03/04, Galina Valerievna, Lyudmila Vyacheslavovna. Address: 6–2 Nikulinskaya St. Buses No.718, 720, 699, 66 (at the building), 226 to City Cardiology Centre bus stop. Then walk straight ahead to the second yellow building on the right. Reception hours: Tuesday, Wednesday 3 p.m. — 7 p.m.; Thursday, Friday 9 a.m. — 1 p.m. The Management.

This notice, posted by the government employees, is a manoeuvre to present themselves in a positive light. They are very anxious to avoid any criticism. However, this announcement paints a much brighter picture of the situation than is actually the case. One can only imagine the true chaos that reigns in the administrative offices, where the complete indifference of the system toward it's citizens is incomprehensible. Paranoid residents might find sinister overtones in the name of the bus stop — Cardiology Centre — as well as the yellow building mentioned in the directions (a *yellow house* is the colloquial term for madhouse in Russian).

Another curious phenomenon is that, for one reason or another, Russian government offices are always closed. Sometimes the endless breaks in working hours reach the point of absurdity:

Working breaks from 9:30 a.m. to 10:30 a.m., 10:40 a.m. to 11:40 a.m., 2:30 p.m. to 3:30 p.m., and 3:40 p.m. to 4:40 p.m.

The first and last shifts between the 'working' breaks are only ten minutes long!

The authorities unleash a torrent of insoluble problems on people, and equally frustratingly, are the first to admit their own impotence and inadequacy. These are the members of the same army of government officials whose numbers have reached two million and continue to grow at the rate of 150,000 employees a year. The confusion resulting from misplaced or undelivered utilities bills gave rise to a wave of counterfeit bills and other documents for making payments for the utilities services. Thus, a notice from the United Information and Accounting Centre reads:

To the residents of the Western Administrative District. It has come to our attention, that certain unscrupulous individuals are distributing counterfeit UBPFs (Utilities Bill Payment Forms), putting them in letterboxes of residential buildings in the city of Moscow. Making payments using such UBPFs, law-abiding citizens are in fact, depositing money into the accounts of swindlers.

Prior to paying your UBPF, check it against the following list. An authentic UBPF has:
— Your full name.
— Charges for all utilities services in an amount comparable to charges for the previous payment period.
— Your IPC (Individual Payer Code), matching the IPC on your previous UBPFA.
— Funds are transferred to a transit account in the Bank of Moscow (UIAC's financial operator)
— The number of tenants and the size of your apartment, as well as ownership type (private, municipal)
— The phone number of your local UIACA

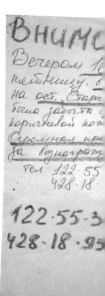

Уважаемые жители!

У кого в квартире холодно, продувают швы наружных стен (углы комнат, углы эркеров, края стеклопакетов). Признаки продувания: отошли обои, ощущение холода при прощупывании стыка панелей ладонью, «дует»)

– срочно звоните на «горячую линию» по недоделкам строителей и требуйте ремонта: летом от дождей эти швы потекут, а следующей зимой в квартире станет еще холоднее.

Заявки принимают только индивидуальные. Обязательно записывайте № заявки.

Напоминаю: дом сдан в эксплуатацию 20 июня 2004 г.

Телефон горячей линии:

209-50-55

A counterfeit UBPF has:

— Only your address

— Charges that are the same for all the residents of the building

— A random number code

— Funds are transferred to another commercial bank. Even though the payee indicated is a municipal organization, the money is transferred to the swindlers' account

— No information about the number of tenants, the size of the apartment, or ownership type

— A random phone number or that of the UIAC from another district. (Should you have doubts about the validity of your UBPF, do not hesitate to call the number indicated and voice your concerns). Your UIAC encourages you to watch out for swindlers!

The following notice tells the real story of the quality of those same apartments for which citizens dutifully pay their utility bills:

Dear tenants,

If it is cold in your apartment, or you feel drafts from the joints of exterior walls (corners of rooms and bay windows or edges of sandwich window panels), or if you notice signs of drafts (buckling wallpaper, wall joints cold to the touch, or just plain drafts):

Call the hotline for builders' oversights and demand repairs. In the summer, the joints will start leaking from the rain and the following winter the drafts will be even worse. Complaints are handled on an individual basis only. Please make sure you write down the complaint number. For your information: the building was ready for tenancy on 20th June 2004. Hotline number: 209-50-55

Внимание!

Просьба к членам
ЖСК-337
Проставьте NN квартир,
где не работают
батареи:
(нет тепла)

кв. 1, 2, 3, 20
16, 28 71 80 N 121
18, 93 146 109
131, 118 98, 108
54 68 107 40
28 106 111 2 кв
14 132 42
148 85 кв 45 69
93 92 96 122

The following notice was posted in the winter by an official from the housing committee:

Attention Superintendents of Condominium — 337!
Please write down the apartment numbers where the radiators are not working (no heating):
Apt. 1, 2, 3, 20, 16, 28, 71, 80, 121,18, 93, 146, 108, 131, 118, 98, 40, 54, 68, 107, 2nd apt., 28, 106, 111, 42, 132, 14, 85, apt. 45, 148, 137, 122, 93, 92, 96...

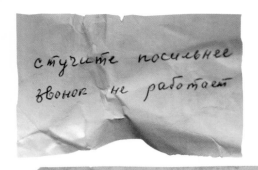

Здесь троллейбусы
не ходят.
N17 идёт со следующей остановки
(за каналом Грибоедова).

←

It's not just the heating — anything can be broken:

Knock hard. Bell not working.

There are streets where buses and trams don't go:

Trams do not take this route. Route 17 leaves from the next stop (behind Griboedov Canal).

Everything is shut and nothing is sold:

We're closed.

Closed for repairs.

Even in museums:

Exhibit change.

Store closed (knock louder!)

This last notice means is that while technically the store *is* closed, you can get in if you are desperate enough. Or the store may be open but the wares for sale are under lock and key:

Dear customers, The keys to the exclusive alcoholic beverages are with the shop assistant in the Baked Goods section.

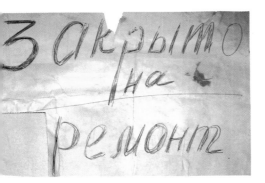

ЗАКРЫТО на ремонт

СМЕНА ЭКСПОЗИЦИИ

МАГАЗИН ЗАКРЫТ (СТУЧИТЕ ГРОМЧЕ!)

С субб. 23 на 24 ваш декабря 95г.
В нашем доме случился
поздний телевизионный
конфуз, который можно ИСПРАВИТЬ.
553-77-43 круглосуточно.

Sometimes it's difficult to work out exactly what's happened:

On the night of Sat., 23rd Dec. 1995, a TV-related accident took place in our building. The wrong can be righted by calling 555-77-43 'round the clock.

В связи с предстоящим ремонтом
приём заявлений на регистрацию
брака прекращен.
Желающие вступить в брак,
прописанные в нашем районе,
могут подать заявления:

Everywhere you turn you encounter endless official prohibitions:

No Entry; Not Receiving Today; I Don't Answer Questions.

This last sign has its humorous counterpart, which perfectly illustrates a typical clerk, and his attitude toward customers or clients:

Services price list:
1. Answering questions — 5 rbls.
2. Answering questions (correctly) — 10 rbls.
3. Answering questions that require some thought — 15 rbls.
4. Correctly answering questions that require some thought — 20 rbls.
5. Written answer — 30 rbls.
6. Answering stupid questions — 100 rbls,
7. Answering stupid questions that require some thought — 200 rbls.
8. Heart-to-heart talk — 500 rbls,
9. Thoughtful gaze — FREE
Note: For those who lack a sense of humour, the fees are in US dollars. The special exchange rate is 1:1.[14]

Everywhere you go the signs say:

No trespassing.

When you need to talk:

The pay phone is out of order. Disconnected.

Renovations can even affect your marriage:

Due to imminent renovations, we have temporarily ceased issuing marriage licenses. Residents of this district who wish to marry please file a petition at the following branches:
Branch No.1: 28 Kr. Flota Embankment
Branch No.2: 52 P. Lavrova St.
Branch No.3: 2/4 Petrovskaya Embankment

14. At time of publication the exchange rate was around 30 roubles to the dollar. In the early post-Soviet days the rate could be as high as 2000 roubles to the dollar or more.

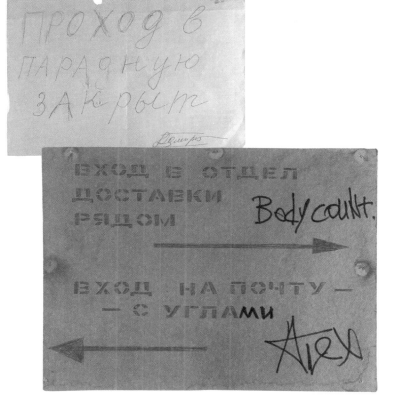

Sometimes the entrance to an occupied residential building may be boarded up:

The main entrance is closed. The Management.

If the residents of this building go out, they have to keep an eye on the time:

Attention! Beginning on 11th September 1996, the entrance will be open from 9:00 a.m. to 6:00 p.m. The rest of the time it WILL BE CLOSED.

The eternally locked doors of Russian public buildings were immortalized in the work of the famous Russian writers of the 1920s, Ilf and Petrov.[15]

The Museum of Ads and Announcements contains a great many notices from such proverbial closed doors:

Entrance to the package delivery department next door.
Entrance to the post office around the corner.

15. Ilya Ilf and Yevgeny Petrov were popular Russian prose writers of the 1920s and 1930s. Their satirical novels *The Twelve Chairs* (1928) and *The Little Golden Calf* (1931) used the central character of a con man to examine and question Soviet society.

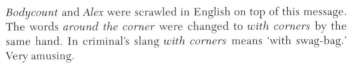

ВХОД
В РЕПРОГРАФИЮ
СО 2ᵍᵒ ЭТАЖА
ПО 4�й ЛЕСТНИЦЕ

Bodycount and *Alex* were scrawled in English on top of this message. The words *around the corner* were changed to *with corners* by the same hand. In criminal's slang *with corners* means 'with swag-bag.' Very amusing.

There may be numerous locked doors, and even if you see the sign *'Entrance'* outside a public building, it is safe to assume that finding your way inside may turn out to be more difficult than at first anticipated:

Entrance to the photocopy shop is from the 2nd floor, stairway 4.

Even the front doors of respectable establishments may be locked:

Entrance to the bank is from Baskov Lane (through the courtyard).

At a certain point a bank might simply stop giving out money:

Happy New Year! To our clients: Beginning on 28th November 1995, until further notice, we will not be cashing checks or accepting cash requests. Good luck in the coming year!

The last sentence was written in hand by the tellers and decorated with cute little flowers. A blunt version of the previous notice reads:

Bank closed. [1998][16]

16. A financial crisis hit Russia in 1998. The recession, caused by a combination of a decline in the price of oil and the non-payment of taxes by major industries, had severe consequences for the Russian people and the ailing President Boris Yeltsin.

→↑→↑→↑→↑→
↑→↑→↑→↑→↑

БАНК
ЗАКРЫТ

С Новым годом!

Вниманию Клиентов

С 28 ноября 1995 года до особого распоряжения приостанавливается прием заявок и чеков на выплату наличных денежных средств.

Основание: приказ Председателя Правления № 268 от "22" ноября 1995 года.

С Новым счастьем!

ХОД в БАНК

с БАСКОВА ПЕРЕУЛКА

◄─────────────

(ЧЕРЕЗ ПРОХОДНОЙ ДВОР)

WARNING.

ТУАЛЕТ
НЕ
РАБОТАЕТ

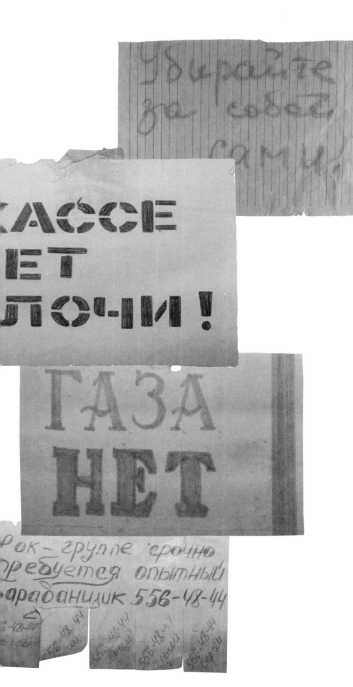

A bar might need a day to clean up it's act:

Dear ladies and gentlemen, from 3rd September 1997 to 4th September 1997, the bar will be closed for sanitation servicing.

It is also common for currency not to be exchanged:

Currency Exchange is closed.

Cash registers to run dry of change:

No change in the register!

And banks to have no money at all:

We are out of roubles.

It is also entirely possible that customers have money to spend, but there is nothing to spend it on:

On 26th March, invalids and people with special needs will not be served due to the absence of products in the store. The Management.

ТАКСОФОН РАБОТАЕТ НА ЖЕТОНАХ МЕТРО

ВНИМАНИЕ !
Пожалуйста,

НЕ ВСТАВЛЯЙТЕ КРАН В БАК.

ОПЛАТА ПРЕДВАРИТЕЛЬНАЯ.

A cashier in a store may only accept payment for one particular product:

This register only rings up eggs.

A chemist may be closed but sell prescriptions in a neighbouring store:

The chemist is closed for reasons beyond our control. Order your prescriptions at The Handbag Shop. The Management.

To make a call on a pay phone, you would need a different currency:

Payphone accepts only metro tokens.

And if you wish to fill up your car with fuel, you may encounter this:

Caution! Please don't put the nozzle in the tank. Payment should be made in advance.

The following handwritten note demonstrates the frustration of ordinary citizens in the midst of this turmoil:

If you're still closed tomorrow, you're fucked! I'm not alone. There are many of us. Why the fuck do you put up a schedule, if no one's ever there?! You should notify people beforehand, like it says in the contract — the one you don't give a shit about. With services like this, we're going to stop giving a shit about you. We can easily put an end to your monopoly. You've been warned...

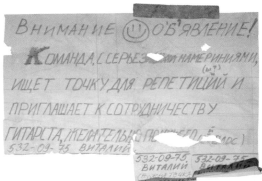

The world of prohibitions and warnings is highly structured. It adheres to strict schedules:

3.06 (Sat) 17.00 — All night vigil. Confession.
4.06 (Sun) 10.00. — Liturgy.
9.06 (Fri) 17.00 — Matins for the repose of the dead.
Prayer for the dead.
10.06 (Sat) — Trinity Saturday prayer for the deceased.
Prayer for the dead. 10.00 Liturgy. The last rites.
17.00 — All night vigil. Confession.

It also implies a system of castes, or rather, a certain category of people, for whom all is permitted. A notice under a regular stop sign at the entrance to a Russian Orthodox Church is deeply symbolic:

Entrance by blessing only.

In an attempt to counteract the chaos of parking practices in Moscow, people make signs that say:

No parking here.

Which are found on almost every gate, archway, or courtyard entrance. Generally, the following 'model' describes the relationship between the people and the authorities:

Attention maintenance workers! Please fix the rubbish-thingy!

To which the maintenance men added:

Well, don't break the damned thing!

УВАЖАЕМЫЕ ЖИТЕЛИ, ВЛАДЕЛЬЦЫ АНТЕН
Если у Вас установлены антенные устройства на кры
на фасаде, то Вам в срок до 31 мая текущего года нес
зарегистрировать их в РЭУ по адресу ул. Гвардейск
корпус 2, у своих техников в часы приема (телеф
справок 444-84-37).

В случае не проведения регистрации антенных усь
указанные сроки то они подлежат демонтажу посл

Проход
категорически
запрещен

THREATS AND PROHIBITIONS

Beach closed for faeces cleanup.

Authorities use an intricate system of threats and prohibitions to counter thoughtless and inappropriate behaviour on the part of citizens. In response, citizens indulge in even more unbridled behaviour in certain spheres. One cannot even put up a satellite dish without permission from the authorities:

Attention residents who own satellite dishes!

If you have installed satellite dishes on the roof or façade of your building, you must register them before 31st May of this year with your maintenance committee at 6 Gvardeiskaya St., Building 2, during the office hours of your respective Chief Maintenance Engineer (call 444-84-37 for information). If you do not complete registration within the required period, the unregistered satellite dishes will be dismantled after 1st June.

Life in Russia — poorly organized, dirty, with buildings almost unfit for human habitation — groans under a plethora of written prohibitions and caveats through which bureaucrats of all kinds trumpet their directives at the citizens. Every government or public institution is thickly carpeted with these notices. Here is a basic example:

Strictly no admittance.

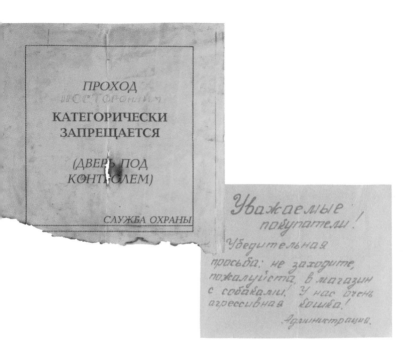

An extended version reads:

No admittance to unauthorized personnel. The door is being monitored by security guards.

Private property is surrounded by absurdly high fences with barbed wire and standard warning signs:

Danger! Vicious dog!

A wittier version appears to have been written by the dog itself:

I can run up to the gate in two seconds. How about you?

Cats guarding a store can be as hostile and savage as dogs:

Dear customers, please don't bring your dogs inside the shop.
We have a very aggressive cat!
The Management.

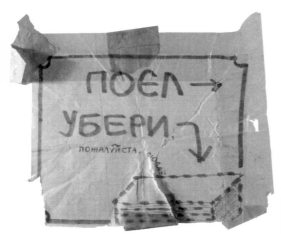

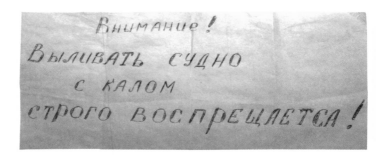

All establishments have highly detailed instructions regulating the actions of their patrons:

After your meal, put dishes away here.

There are detailed instructions about where one may or may not go:

Please do not get up on the podium.

Instructions can be ordinary and quite reasonable:

Close the door tightly.

Or strange and alarming:

Warning! Do not pour out bedpans with excrement!

Sometimes, the authorities issue warnings about the complete unsuitability for use or habitation of a facility or place:

Sudden influx of sewage water into the third Suzdal Lake.
Swimming strictly prohibited. Board of Health and Sanitation.

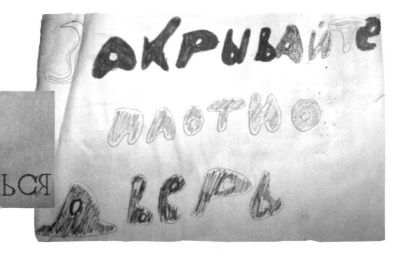

This might not seem too unusual at first glance. But there is one small problem: the third Suzdal Lake is located within the city limits of St. Petersburg, making it a popular resort. On a hot day in July 1994, one side of the lake was full of children swimming and playing, while on the other side, in the middle of a tangle of weeds and impenetrable bushes, stood a long-deserted, half ruined and locked up lifeguard hut — an outpost of officialdom. This was, of course, where the authorities had decided to display this warning, on a tiny piece of paper, taped to one of the hut's dirty windows.

Sewage is a regular problem on beaches as this candid sign shows:

Beach closed for faeces cleanup.[17] [1993]

Administrative prohibitions and demands are often expressed in such a way as to be completely incomprehensible to the public at large. Everyone to whom I have shown the following notice, which several years ago graced all the commuter trains of our vast country, has been unable to decipher it:

Note to passengers: The cost of a ride on the train is not included in the cost of the ticket. The Management.

The vagueness of such notices creates a domain of prohibition with unlimited scope. So a note announcing a policy of selective admission to a produce market has the potential for infinite discrimination.

17. From the collection of Olga Florenskaya. An artist based in St. Petersburg, she works with her husband Alexander Florensky and is part of the Mitki art collective. She is author of *The Psychology of Everyday Typefaces*, St. Petersburg, 2001.

In this situation, security guards can simply bar someone from shopping at the market or detain anyone they like without apparent cause:

We enforce selective admission. The Management.

Bars are also free to discriminate — in this case against anyone crazy enough to consider dressing in sportswear:

To patrons: people wearing tracksuits are not allowed in the bar.

In Russia, however, when everything is not allowed, the proverbial if-you-really-want-to-then-you-can principle kicks in. All you have to do is pay a little extra:

A phone call costs the café 50 roubles.

The implication of this notice is that using the phone is not allowed, but if you 'happen to have' fifty roubles to hand, you can easily circumvent this rule. In addition, official instructions have always been distinguished by an unswerving logic, unfathomable to ordinary mortals:

Follow instructions to unpack. Instructions under lid.

How do you get around this catch-22? Perhaps all you need is a sense of humour:

Instructions for use:
1. Open lid until it clicks.
2. Quickly peek inside box, then jump out of the way.
Caution! Protect your hands and head from falling lid!

ПРИ УСТРАНЕНИИ ЗАСОРОВ
В КАНАЛИЗАЦИОННОЙ СЕТИ
ИСПОЛЬЗУЙ ГИБКИЙ ВАЛ
С НАПРАВЛЯЮЩЕЙ ТРУБОЙ,
НЕ ОПУСКАЙСЯ
БЕЗ НЕОБХОДИМОСТИ В КОЛОДЕЦ

ПОКРЫТ ЛИ ФЛАНЕЦ ТРУБЫ МЯГКОЙ
РЕЗИНОЙ ДЛЯ ПРЕДОТВРАЩЕНИЯ УШИБОВ
И ПОРЕЗОВ РУК

Russians are surrounded by instructions of all kinds about how to live and work. An artist friend of mine donated the following, more metaphorical notice:

Do not climb down the drain when cleaning obstructions in the sewage system. Use a flexible cord in a guiding pipe instead.

Make sure that the flange is covered with soft rubber cap to protect hands from cuts and bruises.

It is unlikely that any driver could ever understand and comply with the following warning sign:

Warning! Tunnel is closed to traffic from Krasnokazarmennaya Embankment to Entuziastov Motorway from 00:00 to 00:00!

Common sense suggests two possible interpretations: the tunnel is never closed or the tunnel is always closed.

Officials often defy the imagination with their deep grasp of both electrical machinery and the principles of mechanics:

Residents: Do not leave the entrance doors open. The draft jams the lift's machinery. Dollift Municipal Maintenance Unit.

They are equally proficient when it comes to electronics:

Warning! To avoid infecting your computer with viruses, do not visit porno sites! The Management.

Official information is distinguished by its high level of concern for the people:

Lifeguard station guards your lives from 8:00 a.m. to 8:00 p.m. [18]

If late night or early morning swimmers need help, it might be a little longer arriving:

From 10:00 p.m. to 6:00 a.m the life jacket is kept in the chief lifeguard's office. The key is with the janitor in apt. 43.

Official notices can contain inappropriate humour. This sign at a lifeguard's hut reveals a glib attitude to human life:

If you drown, you're not swimming here again. Ever!

The authorities' deep concern for citizens is also evident in this public announcement aimed at eliminating drink-driving:

Tipsy? Time to get smashed!
Traffic Police against Drinking and Driving.

It's not only janitors who invent rules of behaviour for the populace — the rubbish collectors do it too:

Gentlemen, Don't throw boxes, boards, wallpaper, or other bulky crap in the bins.

These notices do not stand out as models of politeness:

Information for imbeciles, morons, and other Moscovites:
The rubbish dump is across the street, 500 meters.

Threats to turn the reader into an invalid are also common:

Slam this door and you'll need a disability pension.

18. From the collection of Alex Golovin.

Promises to knock out someone's teeth are also widespread — this note was posted in a shuttle bus:

No toothpaste protects your teeth better than paying for your ride.

Sometimes, the issuers of warnings threaten the offender with material damages:

Warning! Don't park your cars near the entrance, or you'll pay with a broken windscreen. The Management.

When something in Russia is officially permitted, the announcements bear a distinctly capricious, or (as a psychiatrist might put it) mildly hallucinatory, character:

To passengers. As a result of an agreement between the Government of the Russian Federation, the City Government of Moscow, and the Government of the Moscow Region, beginning at midday on 20th January 2005 and ending on 20th February 2005, citizens of the Moscow Region who are eligible for discounts, and have this right, will be able to ride the Moscow Metro free of charge. To enter the metro stations you are obliged to show an ID with proof of eligibility for discounts and a valid residence permit for the Moscow Region.

People 'who are eligible for discounts' are a special category of the poor and disadvantaged, single mothers, war veterans with disabilities, orphans, and so on. One of the few special privileges they have is to ride for free on the metro, all year round. The above month long agreement was only reached the after a thorough discussion between the supreme federal executive powers, the municipal authorities, the regional authorities, a number of smaller committees, and several low-level officials. Only then could the people 'who are eligible for discounts' receive what they were already entitled to.

Sometimes official government announcements are not above resorting to lies. Recently there has been a campaign to cut down the size of radiators in apartments. During the Soviet era, many people increased the size of their radiators to ensure greater warmth during the long winter months. Now, the authorities are out to deprive people of these radiator extensions. The citizens, naturally, are not too keen on letting the officials into their homes. In order to infiltrate these strongholds, the resourceful authorities resort to some callous tricks:

Attention residents! Please allow access to your premises on 13th and 14th September for radiator painting. The heating system will not be turned on until all the radiators have been painted!

If a person does not observe the rules of a hospital, it is unlikely that they will receive any medical care. The process of admission is very strictly regulated. A patient might not even be allowed to bring in money or even a watch. This is how the hospital management and personnel relieve themselves of any responsibility for theft:

Memo

For hospitalisation a patient must have a passport and leather slippers which are to be kept in a plastic bag. You must also have with you a robe, socks, tights, and pajamas. It is forbidden to have money and other valuables (watches, rings, brooches, bracelets, earrings, etc.) on your person. The institution does not accept suitcases and handbags for storage. You must be accompanied by someone to be admitted to the institution. Address your questions about your hospital stay to 218-15-02 *218-98-71 from 2 p.m. to 3 p.m.*

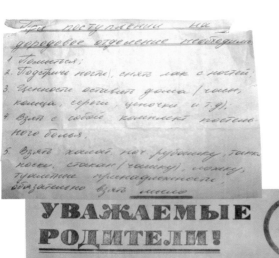

When my son was born, I found this notice in the admissions room of Moscow's Kuznetsovsky Maternity Hospital:

For admission to prenatal care you must:
1. Wash yourself.
2. Cut your nails and remove any nail polish.
3. Leave valuables at home (watches, rings, earrings, chains, etc.).
4. Bring a set of sheets.
5. Bring a robe, nightgown, slippers, socks, cup (glass), spoon, toilet articles, and do not forget soap.

This notice dates from March 1986 when all of the above items were in short supply in most hospitals. Even soap and bedding.[19]

19. The scarcity of goods and severe economic collapse ostensibly set in only in the late 1980s and early 1990s. Yet the prosperity that many Russians associate with the pre-perestroika period (in a spirit of nostalgia) was largely illusory.

And when the child grows up, he will go straight the Telman Sovkhoz[20] student brigade:

Attention!
The headquarters of student brigades of St. Petersburg
Invites you to:
— harvest vegetables in Telman Sovkhoz from the 20th October to the 20th November.
Departures daily from Moskovsky Railroad Station, the trip from the station to the sovkhoz is free of charge;
— harvest potatoes in Krasnaya Baltika Sovkhoz, Lomonosov District, from the 20th August to the 20th September, with room and board...

The state vigilantly looks after the health and lives of its people:

Attention! The HQ of Pesochensky Proving Ground warns you that trespassing on this territory could endanger your life. The testing of all weaponry is currently underway. Citizens, do not violate this warning, and pass it on to your children. This will protect your health and life. Pesochensky Proving Ground HQ.

20. A sovkhoz was a state-owned farm in the former Soviet Union that paid wages to it's workers.

ВВОДИТСЯ РЕГИСТРАЦИЯ гостей С-Петербурга
ПРИБЫВШИХ НА СУТКИ И БОЛЕЕ. ЭТИМ ЗАНИМАЮТ-
СЯ ПАСПОРТИСТКИ ОБЩ-ТИЙ, ПРИ НАЛИЧИИ ПАСПОРТА
ГОСТЯ.
ДЛЯ ГРАЖДАН РФ РЕГИСТРАЦИЯ БЕСПЛАТНА;
ДЛЯ ПОДДАННЫХ РЕСПУБЛИК ЗАРУБЕЖЬЯ ОНА БУ-
ДЕТ СТОИТЬ 5%-тов МИНИМАЛЬНОГО ОКЛАДА —
— ДО 45 СУТОК.
— И ЗА КАЖДЫЙ ДОПОЛНИТЕЛЬНЫЙ МЕСЯЦ —
ПО 77 РУБ.

In the 1970s, wooden posts with barbed wire were erected around the testing ground. Since then the wire has rusted through, locals have been known to make forays into the territory on mushroom and berry picking expeditions.

Migrations within limited areas, as well as over the entire territory of the country, have also long been restricted. Even during relatively liberal times a new type of citizen registration was introduced:

Attention one and all!
From the 1st December 1993
Registration is required for guests staying 24 hours or longer in St. Petersburg. Registration will be carried out by dormitory passport services with the guests' passports. For subjects of the Russian Federation the registration is free of charge. For subjects of former republics of the USSR, the cost is 5% of the minimum wage for the duration of up to 45 days, and 77 roubles for every additional month.

The prevalence of ukases and prohibitions in Russia is the product of a vertically integrated authoritarian system of government, known for its inefficiency. Any initiative from below is ignored or suppressed — all transformations and innovations come from above in the form of orders and decrees:

To residents: In accordance with the Decree by the Moscow Municipal Government issued on 21st September 2004 No.651-pp 'On House Committees,' house committees will be established as one of the ways of managing apartment buildings, according to Article 161 of the Housing Code of the Russian Federation. We urgently recommend that you take part in the general meeting of the residents, as the decision taken at the meeting will be mandatory for all residents of the building. A poll of residents will be carried out by a group of volunteers in order to organize the general meeting. We ask you co-operate with this group of volunteers.

With organizational questions call: 444-84-37, 444-15-21, 444-15-22. The management of ZAO Fitting

This is how local self-government operates in Russia. Bureaucrats fight for spheres of influence and struggle to preserve traditionally corrupt forms of authority. The primary task of officialdom and its endless prohibitions is to impose its own will on the system, and to maintain the status quo. Officials generate hierarchies, regulations, formalities, requirements, and superfluous bureaucratic procedures. Ordinary employees in this system meekly carry out orders. Eventually they lose interest in their work, become passive, and, as a rule, oppose any kind of innovation themselves. They conceal their personal skills and idly wait for directions from above. Prohibitions and strict regulation — this is the reign of stagnation.

Mismanagement and autocratic behaviour are often attributed to bureaucratic indifference, rather than maliciousness. Autocracy is a sociosymbolic system that exists only to the degree that we are convinced of its inevitability. An autocratic official can maintain his authority only as long as we imagine social space to be something mythical and extraneous to ourselves. Perceiving the social order in this way prevents the development of more efficient co-operative networks of relationships. An autocratic manager expects, above all, obedience and submission — on no account is independent initiative encouraged. Any changes are blocked or carried out only in the minds of the officials themselves. The entire social life in the system appears to revolve around the objectification of the thoughts of these petty monarchs. Assuming their own point of view to be universal, and reality to be a materialization of their ideas, the highest government officials make the very existence of innovation possible only as a result of serendipity. For all these reasons, the realm of Russian government is extremely difficult to understand and interpret. This is why bureaucrats usually inspire either invective, or the urge to seek rationalisation for their misdeeds. But all this affords little insight into the meaning behind the reality. In the information age, work should be a source of satisfaction. Its economy is founded on information, non-material assets, knowledge, and trust. In today's Russia, all this is obstructed by a complex system of prohibitions. This intricacy is epitomised in the following memorandum:

MEMO
on safety measures while swimming
1. Military personnel are allowed to swim only in designated
swimming areas, swimming pools, or specially equipped sections
of bodies of water, as part of its division (company) under the
supervision of an officer. The minimum temperature of the water for
swimming must be 64° Fahrenheit. Solitary swimming is prohibited to
military personnel.
2. Remember! In order to avoid swimming accidents you must
observe the following rules:
— you must enter the water only on the command of your superior
officer and only to the designated depth;
— you must swim in the direction and manner determined by your
commanding officer;
— do not swim to the deeper areas of the body of water or dive if you
are a poor swimmer;
— do not swim beyond the line marked by buoys or floats;
— do not engage in undisciplined behaviour towards your comrades.

- **ребенка,** который должен быть в школе, а находится на улице;
- **ребенка,** который побирается;
- **ребенка,** который грязно или не по сезону одет;
- ребенка, который хулиганит, выпивает или употребляет наркотические вещества;
- **семью,** которая ведет асоциальный образ жизни и не заботится о ребенке

ЗВОНИТЕ НАМ!

951-30-67, 265-01-18, 256-22-94

Каждый ребенок имеет право жить и
воспитываться в семье, которая его любит и
заботится о нем!
Каждый ребенок имеет право учиться в школе!
Не будьте равнодушными!
Дети не должны быть чужими!

IT IS FORBIDDEN TO:
— dunk your comrade, to hold him by his legs, arms, neck, or any other parts of the body;
— jump into the water from boats, barges, bridges, breakwaters, or in any locations not cleared for swimming;
— enter the water and swim while intoxicated.
Failure to observe the swimming rules leads to accidents, which usually end in tragedy. Soldier, follow the swimming rules strictly and discourage your comrades from breaking them!

The ubiquitous atmosphere of prohibition, in which authorities resort to autocratic methods to enforce law and order, inevitably gives rise to the phenomenon of denunciation, often disguised in a beneficial pretext, as shown in this example of concern for children:

Attention! These are our children!
Citizens of the Central District of Moscow:
The Prefecture of the Central District, the Board of Education of the Central District, and the Board of Guardians and Custodians of the Central District, are collecting information about children that are neglected or who are not receiving proper care.
Look around you, and if you see:
— a child who should be in school, but is on the street;
— a child who is begging;
— a child is dirty or not properly dressed for the season;
— a child who misbehaves, drinks, or uses narcotic substances;
— a family with antisocial habits or that abuses or neglects a child Call us!
phone 951-30-67, 265-01-18, 256-22-94
Every child has the right to live and be brought up in a family that loves and cares about him!
Every child has the right to go to school!
Don't turn your back on them! Our children belong to all of us!

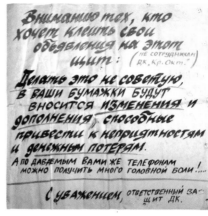

NOTICES ABOUT ADVERTISEMENTS
Physical force will be used against those who post ads here!

Prohibitions are found in every sphere of social life. They are even found on notices that prohibit the posting of ads or other notices:

To authors of ads: Please do not post on this information board.
V. Glukhova.

Often they contain open threats:

Attention those who want to post notices on this board (not employees of Red Oct. Palace of Culture!) I seriously advise you not to do this. Your ads will be altered or augmented with information that may lead to trouble or financial loss. And the phone numbers that you provide will give you many headaches!
Sincerely, Board Keeper, the Palace of Culture

Sometimes the authors do not limit themselves to threats of financial loss, but the promise of violence — usually in the form of a good beating:

Stop! Warning! Posting notices on the walls of pavilions is forbidden. A fine of 1,000 roubles will be enforced and physical force will be used against those who post ads here! The Management.

Street ads are a powerful method of communication. The phenomenon is so omnipresent that it has developed it's own group of specific classified ads offering jobs to people posting notices:

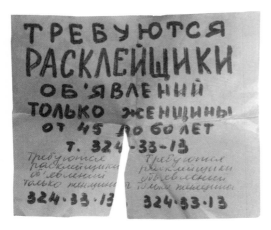

Jobs for all!
Stable company offers regular employment posting ads in the
Moscow district of your choice. We guarantee fair wages relative to
the number of clients who respond to the ads you post (over 50,000
roubles per client).

It's seems patently unfair that a worker is paid for the number of clients responding to the ads, rather than for the number of ads posted.

This work is generally aimed at middle-aged and older women because it is so poorly paid:

Ad-posters wanted
women only
between 45 and 60
Ph. 324-33-13

One could say that street ads facilitate the existence of the illegal market, and, thus, become an inextricable part of it. Often, street ads are the mechanisms that channel sales and purchases in the 'grey' market.

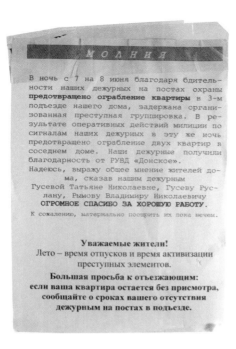

В ночь с 7 на 8 июня благодаря бдительности наших дежурных на постах охраны **предотвращено ограбление квартиры** в 3-м подъезде нашего дома, задержана организованная преступная группировка. В результате оперативных действий милиции по сигналам наших дежурных в эту же ночь предотвращено ограбление двух квартир в соседнем доме. Наши дежурные получили благодарность от РУВД «Донское».
Надеюсь, выражу общее мнение жителей дома, сказав нашим дежурным
Гусевой Татьяне Николаевне, Гусеву Руслану, Рымову Владимиру Николаевичу
ОГРОМНОЕ СПАСИБО ЗА ХОРОШУЮ РАБОТУ.

К сожалению, материально поощрить их пока нечем.

Уважаемые жители!
Лето – время отпусков и время активизации преступных элементов.

Большая просьба к отъезжающим:
если ваша квартира остается без присмотра,
сообщайте о сроках вашего отсутствия
дежурным на постах в подъезде.

DANGER AND PARANOIA
Close the door tightly and shout for help.

At first glance, the warning signs that appear on every corner seem to be quite reasonable. They remind citizens to be alert to danger:

Thanks to our vigilant watchmen who were manning their posts, on the night of 7th / 8th June a robbery from an apartment in our building was prevented. An gang of organized criminals was detained. As a result of the well co-ordinated actions of the police, who were notified of the danger by our watchmen, the robberies of two other apartments in the neighbouring building were also prevented.
The Donskoe Police Department extended its thanks to our watchmen. I know I am speaking for all of us when I say that Tatiana Gusev, Ruslan Gusev, and Vladimir Rymov deserve ENORMOUS THANKS FOR THEIR GOOD WORK. Unfortunately, we have no other means of expressing our gratitude.

Dear residents,
Summer is holiday time. It is also the time when criminals become most active. If you are going away for an extended period of time, leaving your apartment empty, please be sure to inform the watchmen of the expected duration of your absence.

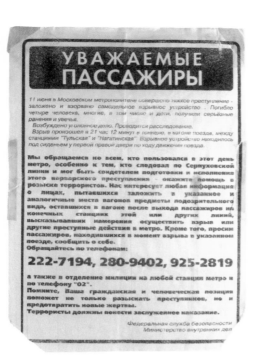

Warnings about terrorist attacks also sound very reasonable:

Dear passengers,
On 11th June, a heinous crime was committed on the Moscow metro: a home-made explosive was planted and detonated. Four people died, many people, among them children, were seriously injured. A criminal case has been opened and a police investigation is underway. The explosion took place at 9:12 p.m. on a metro carriage in the tunnel between Tulskaya and Nagatinskaya stations. The explosive had been placed under the seat by the first door on the right, in the direction the train was headed. We appeal to all people who used the metro on that day, especially those who rode the Serpukhovskaya Line and might have witnessed any suspicious activity prior to this barbaric crime: help us find the terrorists. We are interested in any information about persons who may have tried to place suspicious objects or packages in the aforementioned or similar locations, objects that remained in carriages after passengers exited at the end stops of this or other lines, and people who have verbally expressed an intention to set off an explosion or commit other criminal acts in the metro. We also ask all passengers who were riding this train when the explosion took place to report to us.

Such warnings are numerous, and if we try to fathom their number, we will be astonished by the abundant calamities and disasters that threaten us from all sides. Some warnings are posted when and where no danger is present. Like this sign, spotted on a hot day in the middle of summer:

Danger! Falling icicles!

Even in the Northern hemisphere it must be surprising to observe snow falling from the rooftops in July:

Danger! Snow or ice may fall from roof!

Avalanches are the most amazing summer phenomenon in Russian cities:

Caution! Danger zone! Avalanches from roofs!

An avalanche in the center of Moscow nicely rounds out the portrait of the wild Russia of the North, where, any foreigner might think that polar bears roam the streets, and the vodka soaked locals do their national 'squat dance' to the jangling of a balalaika.

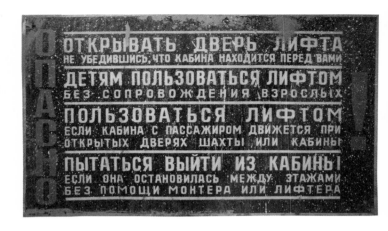

Signs in entrance halls warn of the obvious dangers posed by automatic lifts. Here is a typical example of these signs, which usually take the form of a durable metal plaque:

It is DANGEROUS:
— to open the lift door before it has come to a full stop in front of you
— for children to use the lift without an accompanying adult
— to use the lift if it is moving, or while the lift or lift shaft door is open
— to attempt to exit the lift if it has stopped between floors, without the assistance of a repairman or lift operator.

Dangers lurk not only in lift shafts, but also on the ground, right under your feet:

Caution! Watch your step. Wooden ramp!

It gradually becomes evident that most of these signs warn the public against non-existent dangers. Official warnings have the express goal of keeping the intimidated public in line. What are the chances of something spontaneously combusting right under your feet?

Attention!
Residents,
Do not throw newspapers and fliers on the floor.
The entrance hall will catch fire.
Activists Brigade

Ambiguity is often used to promote a sense of fear. The underlying threat is elusive, and often obscure:

Dangerous passage here

This sign was made on a sheet of metal and looks very convincing.

Shops regularly warn about imminent robberies:

Customers! There have been cases of pick-pocketing in this shop. Watch your handbags closely at all times. The Management

The following series of announcements calls on citizens to rise up against these threats:

Dear residents!
Be careful and vigilant. You need to combine your efforts to secure the safety of yourself and your loved ones. Elect a resident head in each building and organise a watch shift in building entrances and nearby areas. [2000]

In recent years, of course, in addition to warnings about everyday dangers, warnings about terrorist attacks have become frequent. This sign was photographed in Krasnoyarsk airport in 2005:

At 4:30 p.m. on 6th June 2004, at the River Station in the city of Krasnoyarsk, an unidentified man reported a possible terrorist attack on the steamboat 'Chkalov' while it was on route between Dudinka and Krasnoyarsk.

SUSPECT DESCRIPTION: male; 45 – 47 years of age; average height; slight build; dark shoulder-length hair; deep crease lines around the mouth; dressed in dark trousers or jeans and a grey button-down shirt. Please pass this information to police and civilians. If you have any possible leads, inform the Krasnoyarsk River Station Police at 34-78-27, 34-78-18.

Colonel V. Troshin, Head of Krasnoyarsk River Station Police

ВНИМАНИЕ РОЗЫСК !

По подозрению в приготовлении и совершени
зразовательных школах и учреждениях культур
Приметы разыскиваемой: возраст 27-30 ле
ожения, лицо южного типа без особых примет, в

The following notice was also photographed at the same location. Neither is very persuasive from the perspective of the threats they describe:

Wanted!
On suspicion of planning and carrying out terrorist attacks in schools and cultural institutions...
Suspect: female, 27 – 30 years of age... Build, southern facial type without distinguishing traits... If you have determined her whereabouts... Important information, please call immediately...
Police in Krasnoyarsk airport at 635-0...

This excerpt from a fire safety notice tells us what to do if the threat becomes a reality:

Close the door tightly and shout for help.[21]

21. Found by Mitya Aleshkovsky.

One of the most horrific notices in my collection is the following letter written by a semi-crazed woman, appealing to her children. It is unlikely that they would have ever read it, as she had pasted it onto the walls of neighbouring buildings. It reflects all the complexes and paranoia particular to the world of the Soviet citizen. Everything this woman has feared during the course of her life comes to light in these lines:

My dear son Yury Valerievich,

I, Valentina Fedorovna Makarov-Zhuravlev, your mother, miss all 3 of you, my sons, very much, they stole 2 of you from birth, I saw them being stolen K. Enin-Medvedev. I am Estonian-Nanai-Negro with neighbours who have been around all my life, all 50 years!!! just like now all the Zaitsev-Kiyazevs, all the Osipov-Zhuravlevs, all the Uvarov-Ambroseikovs — singers, figure skaters — all snakes, in the carcasses of those they have killed, they all use aliases, all of them. Since 1949, since 1977, since 1961, since 1983 here where I live now, they all have sexual feelings for me, V. Roshchin, Khad Benshikh Mohamed — all of them, the same thing all these years from funny farms and jails for 50 years they haven't allowed my loved ones to see me and I don't know any of my own people!!! They should be ashamed that I'm the only one they lie about!!! They are the thieves of my documents and money. [Added in the margins:] *'I have nothing left, sonny, they're lying that they put me away' — psych. patients — their neighbours — 4 attempts on my life (fainted dead away) from 1992 to 1995 and they won't give me my 4 old passports back and won't give me a new one, because everybody steals through murder they: factories where I used to work, like blatantly took my wages using my papers, using murders, police, social ser(vices), people in the maintenance office and killed mailmen. I can't fight them alone!!! They aren't letting me out and lie on my behalf!!! Using my stolen documents!!! 50 years!!! Neighbours — members of sects — meateaters (they eat people) — gangbang raping diseases and they crucified him, as in the church, cut off his male sexual organ and nailed it with spikes — neighbours is all.*
Take good care of yourselves, my dear sons.
Your Mum

All 50 years of my life I've never been anywhere with anyone, besides my work before 1984, I cook my own food, buy it in a store and cook it, as before. I have never been with anyone but your father!!! Just like now!!! Your dad is a snake so I divorced him!!! from 1965 to 1980, like being resurrected! sensitivity on the body, so they all see me, everybody who lives nearby and those from the countryside, they spread lies, they blocked me at every turn!!! Everyone has cars, clothes, new furniture, and they burned my apartment, my clothes,

broke things, burned this day my son Dec. 1994 elder (firstborn) —
neighbours abused him first keeping him hungry from 1993 and then
they took them all to the mental hospital after the fire!!! for nothing
In the hospital they demanded food, clothes, intimacies and my
money!!! and divided it between themselves neighbours — sect
members, and still!!! all their murders!!! They lie and right there,
face to face with me!!! they confuse things on purpose. Wherever I go,
they run ahead as fast as they can and still haven't given me my
money back! (They pay me 260 thousand roubles a month — low
output, not me, though). Please help me get back what is mine.
My highest wage 2,500 a month in old money — 2.5 million now
roubles. 1) According to an official notice from 1949, from 1986, and
from the first son. 2) My pension for continuous employment for 21
years from 1973, from 1982 I have professional deafness, I don't need
treatment. They pay my pension 3 x 100% immediately from 1973.
Your Mum Valen. Fedor Makar-Zhuravl.

(This notice was found on a lamp post at 13 Dresden Street, St.
Petersburg, 1995).

Дорогой сынок Юрий Валерьевич!!!
— ваша мама —

Я очень скучаю о Вас 3-х моих сынов 2-укрáли с
родов, я их видела один раз проходой девочка —
которих укрáли у меня Еnич-Медведев К 3-с сохóдни
которне меня окружают всю мою жизнь 50 лет моих!!!
как и сейчас — Зайцевч-Князевч все, Осиповч-Журавлевч все,
Уваровч-Амбросийковч-певицч, фрагуристки - овно знею, в
группах убитих ими, они все и под чужний фамилиями они.
с 1949г, с1977г, с1961г, с1983г-здесь где я живу
сейчас, под половним чуствам на меня Рощин Ю, Кав Беких
Ногомсá-овно они во все годá ео псих домов и тюрем они
50 лет они не допускали ко мне мою родню и я никого не
знаю из своих!!! Они ворн моих документов и денег
псих-домовки - сосáдч ими —
— 4-м покушение на меня (смерт. обмороки) с 1992года до 1995года
и не отдают мне старіе 4 паспорта и новий не видают, т.к.
разворовали через их убийства они: заводи где я ра-
ботала, почтн ч накапся с моих документов они
писали себе мои деньгу через убийства милиции
райсó (вет,дел), зним, конторн рабочих ч убивали
почтових рабочих. Мне трудно óвáой отражать их!!!
Они не допускают меня никуда ч пут от моего имену!!! По
висраним ими документам моим!!! 50ме!групшой сосáду —
— Синташки-мясовки (едет человека)-носилуют вопрезнему ч
делали расшяте, как в церкви, отрезали муж. пол. орган и при-
гошаивали гвоздями-сосáои овно. Берегите себя сыночки мои

Health information boards in hospitals and clinics represent yet another category of notices intended to send shivers down your spine. The most frightening I've ever seen was on the huge information board in the Severomorsk Military Hospital in 1982, where I received treatment while serving in the Navy. Under the title *What a Wonderful World*, it displayed around two dozen black and white photographs from the hospital's Skin and Venereal Disease Unit, showing patients in the last stages of syphilis... More often than not, however, these boards elicit nervous laughter and a slight sense of paranoia, rather than horror:

Your ABCs

Unit 11 Health Information Board

During the first months of marriage one in five healthy women become pregnant; during the next eight months, half; and within a year and a half, almost all. But some still have problems with living space, others have a firstborn who is still young, yet others are still studying, and there are those who are too young to be good parents. There are plenty of circumstances and reasons where it is difficult to have a child. Unwanted pregnancy — it causes women and their spouses much grief. But the probability is very great, and it lasts between 20 to 25 more years. Of course, you can have an abortion, but it is always dangerous, especially if it is your first pregnancy. Adnexitis, miscarriage, premature ectopic pregnancy, and sometimes even incurable infertility, can often be the consequences of such an operation. You can take drugs to poison the foetus and your system. But this is even worse, damaging your liver and kidneys — the organs responsible for cleansing your body and removing toxins from it...

Another variation on this theme reads:

Trichomoniasis
Health Information Board 13. Women's Clinic No.7, Vyborgsky District

Trichomoniasis is an infection caused by the trichomonas vaginalis, a flagellated protozoan parasite ranging in size from 7 to 60 microns. Its preferred environment is the urogenital system... Water of natural water reservoirs and tap water do not provide a suitable environment for trichomonas vaginalis. Tests show that in 5 – 8 minutes up to 86% of the parasites placed in a test tube with the water from a natural water reservoir will die. They will die even faster in tap water or sauna water... Thus, the main means of transmission of trichomoniasis in women, as well as men, is through sexual intercourse. Non-sexual transmission is possible, but it is extremely rare, and is almost always caused by bad hygiene (through bedding, face cloths, towels)...
You should observe personal hygiene and teach it to your children. Prolonged infection by trichomonas vaginalis may lead to chronic diseases, and even scarring of the internal sexual organs.

Hygiene and sanitation measures during the treatment of trichomoniasis and after:
1. Daily hygienic cleaning, washing the surface of the body with soap.
2. Use personal face cloths and towels. Wash and dry them carefully after use.
3. Change your bedding daily and be sure to iron it.
4. Do not take children into bed with you!
5. Treat bathtubs, bedpans, and toilet bowls with 2% solution of chloramine or lysol.
Persons responsible for the Information Board: Dr. O. Abramova, Academician L. Starchina

Let us move on from citizens' paranoid delirium to the sociopolitical announcements, through which the authorities address these very citizens. The following political proclamations are made by anonymous authors. Through them they address the world at large, registering their existence and sharing their views on the most current political and social debates. These notes also function as a public forum, similar to the 'readers' letters' in a newspaper. They certainly assume the characteristics of mass media:

Dear Petersburgers,
We must write to Moscow and demand that the results of the 25th April referendum be annulled — because the information is in the hands of Yeltsinite democrats, and through devious means they will capture the vote of the population. Germans also voted and fought for Hitler when he had control over the sources of information. But after the war, information passed into other hands and the Germans began to consider Hitlerism an aberration and a mistake. [1993]

This notice is from the beginning of 1996:

Leningraders![22]
Congratulations on 1st May, the Day of International Solidarity of Workers in the Struggle for Their Rights!
We invite you to participate in a demonstration and rally under the following slogans:
'Down with the Anti-Populist Regime!'
'Give Power Back to the Soviet and Soviet Constitution!'
'Peace! Bread! Work! Wages!'
'Retire Sobchak!'[23]
We will gather at Oktyabrsky Concert Hall at 10 a.m. on the 1st May
The demonstration will begin at 11 a.m.
The rally will begin at 12 midday on Palace Square.
Labouring Leningrad Movement;
Council of Workers, Peasants, Professionals, and Civil Servants;
The Russian Communist Workers Party;
LenkomSoyuz
For information call 276-19-41; 276-62-53

22. From 26th January 1924 to 6th September 1991, St. Petersburg was called Leningrad. Here the appeal to Leningraders denotes an anti-perestroika viewpoint.
23. This refers to Anatoly Sobchak, a liberal politician who helped to write the Constitution of the Russian Federation. He was the first democratically elected mayor of St. Petersburg from 1991–1996, and was a mentor of Vladimir Putin. He died in suspicious circumstances in 2000.

A radiation warning has been drawn over the sign, beneath it the message:

Communist losers

Ленинградцы!

Очередное преступное повышение квартплаты, предпринятое Собча..., вопреки решениям Государственной Думы, ставит большинство семей на грань нищеты. За наш с вами счет в очередной раз повысят зарплату чиновникам, проведут очередные презентации. Почему мы молчим?

Нас приучают не сопротивляться тем, кто навязывает нам свою волю, кто наше уважение ни своим умом, ни своими делами не заслужил, но в наш карман залезает.

Нас запугивают и запутывают законами и инструкциями, пытаются разъединить, натравить друг на друга, приучают к мысли, что каждый должен выживать в одиночку. Но поодиночке не выживешь. Наша сила в единстве — только тогда власти будут бояться нас. Объединяйтесь и боритесь.

Вы должны знать, что мы не обязаны оплачивать незаконные повышения квартплаты, что мы не обязаны платить за услуги, которые нас не удовлетворяют, не обязаны оплачивать отключенную воду, отопление, газ.

Научитесь защищать свои права. Объединяйтесь, создавайте инициативные группы в квартирах, подъездах, домах, микрорайонах. Направляйте к нам своих представителей для получения подробных инструкций по невыполнению преступных решений властей города. Закон на нашей стороне.

Союз Народного Сопротивления (СНС)

The campaign against Anatoly Sobchak was the first large-scale smear campaign in post-Soviet history:

Leningraders!

Another rise in utilities charges — ordered by Sobchak despite the decision of the State Duma — will drive most families to the verge of poverty. Again, we have to pay for a raise in the salaries of government officials, so that they can stage more 'presentations.' Why are we silent?

They train us not to oppose the very people who impose their will on us, who do not deserve our respect either for their minds or their deeds, but who like to dig deep into our pockets. They scare and confuse us with their laws and instructions; they try to split us and make us turn on each other. They train us to think that it's every man for himself in this world. But you can't survive if you're on your own. Our strength is in unity. Only then will the authorities start to fear us. Unite and fight!

You should know that we don't have to pay illegal increases in utilities costs, that we don't have to pay for services that are not carried out, or water that is turned off and gas and heating that don't work.

Learn to defend your rights. Unite and form residence committees in your buildings, blocks, and neighbourhoods. Send us your representatives for detailed instructions on resisting the illegal decisions of the municipal authorities. The law is on our side.

The Union of People's Resistance (UPR) [1996]

СОЛДАТЫ! ОФИЦЕРЫ!

Выполните свой долг перед
Законом и Отечеством —
поддержите Президента России
Б.Н.Ельцина и избранных Вами
народных депутатов! Танки
в/ч 61896 под командованием
майора Евдокимова С.В.
встали на защиту Дома
Советов России. Следуйте
примеру майора Евдокимова и
его солдат!

Народные депутаты РСФСР

20.08.91, 1 час 30 мин.
Дом Советов России

There were also many communist-leaning proclamations in St. Petersburg:

Leningraders! Brothers and sisters! Descendants of those who threw off the bloody Siege[24] and saved Lenin's city! Don't let the fascist-democrat Yeltsin desecrate the holy graves of your fathers and grandfathers. Down with the oath breaker! Get out of Leningrad!

Only six years earlier, Boris Yeltsin had been just as fervently defended by the people:

Soldiers! Officers!

Carry out your duty to the Law and the Fatherland! Support the President of Russia, Boris Yeltsin, and the people's deputies you have chosen! The tanks of Battalion 61896 under the command of Major Yevdokimov have risen up to defend the Russian House of Soviets.

Follow the example of Major Yevdokimov and his soldiers!

People's deputies of the RSFSR
20. 08. 91, 1:30 a.m.
Russian House of Soviets

24. This refers to the Siege of Leningrad, which took place during the Great Patriotic War (World War II), when the German army surrounded the city. It lasted from the 8th September 1941 until 27th January 1944.

The form of the following ditty found in a country shop, suggests it's origins are of a more traditional folk genre:

Cows and goats give you their wealth
Drink your milk and save your health
Communism's just round the corner.

The next notice constitutes a masterpiece of political inspiration:

Even the nobility lent us a hand
In our fight for socialism.
And now the ones who robbed our land
Are marching off t'ward capitalism.
— Citizens of Leningrad [1996]

A number of political messages explicitly target Russian national feelings, giving expression to right-wing patriotic rhetoric. The messages denounce 'enemies of the people' — who are seen as the sources of all misfortune, scapegoats for the collapse and ruin of the country.

Here this honourable role is reserved for representatives of 'the Southern nations':

The Nationalist Republican Party of Russia.
Russian Girl! Hordes from the Caucasus and Central Asia have swarmed into your country. They murder, rob, and rape. They have made a mockery of your country, like the German invaders. Will you give yourself over to desecration by the enemies of your people? You are the daughter of the great Russian nation! We will defend your honour and national pride. The Nationalist Republican Party of Russia will denounce as a crime any attempt by the Southern invaders to compromise Russian women. We will punish severely anyone who tries to disgrace you by offering you money, or who acts in a threatening and violent manner. We will not let you turn into a white slave of the horde. Together we will cleanse Russia of the black locusts from the Caucasus and Central Asia! The Nationalist Republican Party of Russia is fighting to root out the depraved 'black' guests from the Russian land! We are fighting for the honour of the Russian nation, for social and national justice, for law and order in our country!
Our telephone number...

In the 1990s patriotic military associations that openly propagated 'imperial aspirations' began to surface:

The Russian National Legion, a patriotic military association, is recruiting men aged 16 to 35 for training in hand-to-hand combat. Recruitment is carried out on a competitive basis. Preference is given to persons with strong nationalist (imperial) convictions.

This is a classic recruitment ad for the extreme right-wing organization, Russian National Unity:

People of Russia! Join the Russian National Unity patriotic movement (RNU). A. Barkashov, chairman.
Where every Russian, no matter what age, sex, or occupation, can contribute to the cause — the rebirth of Russia!

The ad is accompanied by images of stylized crosses that resemble Nazi swastikas. The Russian National Unity was quite openly active in the 1990s, but by the start of 2000 it had splintered and was strictly monitored by the government. The leader, Alexander Barkashov, left and began to organize a new independent movement. His second in command, Oleg Kassin, who was also head of the Moscow branch of RNU, now co-ordinates the People's Council, a popular movement that unites Orthodox Christian patriotic groups in Russia. In the mid-1990s, RNU was the largest radical nationalist organization with around 20,000 members.

I should add that Orthodox patriotic rhetoric with an imperialist slant has always had a significant appeal in Russia. The popular politician Alexander Lebed[25] used these patriotic and imperialist slogans to ascend to power:

Law and order.

Today in Russia many things are lacking, the most important —
law and order.
The government openly spits in the faces of its citizens, remembering
them only on the eve of elections. The citizens answer in kind — they
don't obey the law.
It has become easy for us to steal, whether in the Kremlin, or deep in
the countryside.

Sleazy life.

I, Alexander Lebed, General of the Russian army, have announced my
candidacy for President of Russia, because I am sure I can restore the
country to order.
Order is not dictatorship. Order is when people can live without
being afraid. It is a reliable, unshakable life, living by the law, when
honest labour is profitable.
I vow to smash the system of bureaucratic and criminal outrages.
I have no connections with power, either old 'communist' power, or
new 'democratic' power. I will act without looking back at them.
I can't promise you a paradise. We'll have to work ourselves, for
ourselves. It's hard, but we won't have anything to be ashamed of.
It's an honest living.

I have faith in this, and the will to do it.
Your choice is my strength.

The fliers of this ex-general turned politician were literally plastered across all Russia. They intricately wove the rhetoric of the democratic opposition — and even revolutionary rhetoric — together with authoritarian militaristic phrases.

I found the following text on Myasnitskaya Street, Moscow in 1997. It reveals, to some extent, what goes on in the mind of a 'simple Soviet citizen' who has been subject to Soviet propaganda for many decades. Now this citizen is ready to vote for such politicians. Her rant will leave even the most imaginative of us speechless:

25. Alexander Lebed was a Lieutenant General in the Russian army who resigned his commission and became a popular, moderately nationalist politician, with a military style. His death in a helicopter crash in 2002 is surrounded by conspiracy theories.

Get the fascists out of the USSR, who are from countries spies militia, police, military, soldiers, and sailors, and others in our uniforms, who look like ours and like our army. Them cunning fascists killed soviet armies, children and peoples. In Kazan, in police, in kindergartens, in schools, in colleges, and other places it's empty there, those that are ours — soviet — are gone. And in the Moscow school for the deaf our soviet children are gone. Fascists, they have special masks more like real phantoms, it suits them and a lot of experience, and so fascists in our uniforms came to Moscow, captured and won over the soviets and called from other countries spies (ministers, deputies, executives, brigades, watchmen, janitors, yardmen, directors, editors, reporters, lawyers, judges, prosecutors, salesmen, cashiers, cooks, priests, speculators, pregnant women and children, gypsies, bums, girls, boys, the blind, the invalids, musicians, and others are here on purpose, to mess things up and ruin things and a lot neatly tricked us soviets, that's what spies write about specially, destroyed a whole lot the soviet law of the USSR and then they were on every each — their place authorities persons — Capitalist power — all the prices will cost more. It's cruel, and they're happy and they smirked that the soviet people don't know anything and don't understand what happened to them. Get the spies out of the school for the deaf speaking children.

Soviet woman from Kazan

This is a fairly paranoid example of quintessential spy-phobia.

The next message dates back to about the same time (the beginning of 1997). It campaigns for the signing of an agreement between Moscow and Minsk:

Muscovites! On the 2nd April, the government of our country will have, perhaps, the last chance to correct the mistake it made in the Belavezha Accords,[26] to tear down the artificial borders between Russia and Byelorussia, between us and our Slavic brethren. Since time immemorial, since Kievan Rus, we have lived in peace and harmony. United, our peoples have fought against foreign invaders in ancient times; united we combated the fascist hordes. We Russians will never forget that a quarter of the population of Byelorussia died fighting for our common Motherland in the Great Patriotic War [World War II]. Recently, TV and newspapers have launched an outrageous campaign against our brotherhood, against our union, and, in effect, against all of us and the future of our children. Yet again, those who destroyed our economy, who drove the Russian people to the verge of poverty, and who pushed the country to the brink of a social disaster, lie to us through the TV screen. They scare us with the wild beast Lukashenko,[27] they scare us with non-existent expenditures on unification, and they say it is a threat to Russian democracy. They try to scare us, but we are not afraid. We want, and we will, live in a unified country, in which Russians and Byelorussians are brothers. Muscovites, we call on you not to believe the lies of the opponents of unification! We say yes to the union between Russia and Byelorussia! Yes to the brotherhood of our peoples! — Our City movement

Nowadays, however, the political activity of Russian citizens is carried out on a local level, rarely going beyond neighbourhood rallies to protect playgrounds or green spaces in their own backyards:

26. The Belavezha Accords were signed on 8th December 1991 by the then leaders of Russia, Belarus and Ukraine. The Accords effectively dissolved the Soviet Union and established the Commonwealth of Independent States (CIS), a geopolitical alliance between the former Soviet Republics.
27. Alexander Lukashenko has been President of Belarus since 1994. Now in his third term, his authoritarian reputation and Soviet-style political methods have increasingly led to protest from the public. According to independent observers at his last election victory he 'permitted State authority to be used in a manner which did not allow citizens to freely express their will at the ballot box.'

Muscovites! Get up, or your bed and your home will disappear while you're asleep!

Dear residents,

Mozhaisky District has turned into a huge construction site. Evidence of unlawful construction practices goes on right underneath our windows. Authorities turn a blind eye to:

— the illegal allocation of land for construction;
— the 'sardine-packing' of living spaces;
— the transgression of our property;
— the degradation of ecology in the district;
— the destruction of the last oases of green.

Our homes are at stake! [2004]

The language of Russian politics is undergoing a crisis in defining the idea of power — the idea that is the very ideological foundation of government. The ideology of power and its language today are based not on contemporary realities, but instead on completely mythological notions. Space is divided into *centre* and *periphery*, *higher* and *lower*, *order* and *chaos*, *catastrophe* and *salvation*, *death* and *resurrection*, *vertical* and *horizontal*, *victory* and *defeat*. People are divided into *us* and *them*, *good* and *bad*. All this is characteristic of a mythological model of the world. As a result, the centre — Moscow — becomes the only space suitable for living. The periphery, similar to the mythical 'beyond' of fairy tales, is a realm of poverty and desolation at best. At worst, it is the realm of chaos and warfare. Peace and order are only possible in the centre of such a world. All the resources gravitate towards it, creating an island of flourishing order. Russia itself is personified as the suffering heroine of this myth.

Even in short slogans, such as:

As Russia lives, her fleet lives too! 300th Anniversary. Hail! [1996]

The theme of the life and death of Russia emerges starkly.

Many politicians used this type of rhetoric to rise to power. In one of Alexander Lebed's campaign ads, he calls upon the people to struggle against chaos for the restoration of order:

I will end Chaos in the land of Russia.
I will end all wars within Russia and on her borders.
I will destroy all criminals and outlaws.
There will be one law for all — from President to worker.
I will guarantee all forms of private ownership.
After we finally introduce order to the country and achieve a high standard of living, no one will dare tell us how to live. People who fled from the weak Soviet Union will be able to return to a new, flourishing Russia.
We will restore our Nation!
Give me strength, the strength of your support!

THERE WILL BE A TIME WHEN WE WILL BE PROUD OF RUSSIA!
Alexander Lebed

Here, all possible resources are mobilized for the struggle against chaos and to maintain the status of the *higher* echelons, whether in the form of a space programme, or the establishment of vertical power. The *lower* echelons of society are tantamount to a toilet where your enemies are cornered and done in.[28] Only us, primarily the higher us from the centre, will be prosperous and well fed. This ethos encourages the search for enemies and traitors:

Judas Yeltsin — up against the wall![29]

In messages of this nature, revolutionary rhetoric brands the people's chosen President an enemy who has 'executed the Soviet government':

Citizens, comrades, brothers, sisters! Join us at a rally of MEMORY and PROTEST on the THIRD anniversary of the cynical and cruel state coup, which began when Yeltsin signed Ukase No.1400.
The Constitution was trampled, Soviet power was executed. Innocent blood was spilled; hundreds of people disappeared or were maimed and killed.
21st September 1996
Rally on Smolenskaya Square at 12:00 noon.

28. As Vladimir Putin infamously stated in his 1999 speech on Chechen terrorists: 'We'll follow terrorists everywhere. We will corner the bandits in the toilet and beat the hell out of them.' The Russian slang he used here translates as, 'wet (i.e. execute) them in the toilet'.
29. Olga Florensky, *The Psychology of Everyday Typefaces*, St. Petersburg. 2001.

For some people, the presidential candidate is an enemy:

Urgently needed new President Yavlinsky...

Scrawled over the notice:

Mangy Yid.

Rather than reform, citizens long for 'struggle' and 'revenge.' Minorities must accept the will of the majority or leave the country. Occasionally, the theme of immigration appears in the political pamphlets themselves:

The Union of Right Forces — The Just Cause, New Strength, Young Russia, The Voice of Russia, and Democratic Choice of Russia. We are for Kirienko, Hakamada, and Nemtsov, because they defend freedom. If they are elected, we'll be able to achieve everything in our country, which we don't want to leave.

Here, the campaign managers of the Union of the Right Forces try to speak on behalf of the intellectual minority of the country. It is curious that they seem to contemplate leaving the country if they are not elected. Russia's paternalistic political mythology likes to fantasise about a category of 'innocent, young children' — essentially, citizens who have no power. In 2006 President Putin made a droll comment to the press: 'I guess nobody put on nappies for this press-conference, so it's time to wrap it up.' Indeed, the primary task of the leader of the country is to protect his public, to take care of them. The inference of his remark is that his subjects might soil themselves if they knew what really went on.

Today, the words of high-placed officials do not convey objective information, but are a form of literary text aimed at the mythological consciousness of the people. President Putin uses many phrases that work in this manner. To a Russian the proverbial idiom 'to wet (i.e. execute) in the toilet,' subtly unites the motif of drowning in the lavatory with the theme of submerging the enemy in the depths of a sepulchral underworld. The terrific saying 'you'll be swallowing dust' (also one of the President's pet phrases), has the historical connotation of 'stomping the enemy of the Russian land into the earth and mud,' while at the same time being close in meaning to 'wet them in the toilet.'

'Drowning in the toilet' becomes a substitute for death penalty, divine will, and death itself. 'Uncovering the enemy' and the subsequent rituals of its elimination replace the need for proof of guilt. If you look like an enemy, you must *be* the enemy. And Russia has been quick to find the portrait of an enemy — the 'southern facial type' with dark skin and black hair; the face of people who 'all look alike.' The war on terrorism has gradually become the war of blonds against brunettes. There are, of course, many other abstract enemies; but, as a rule, they are found abroad, beyond the Russian border. A regular citizen can find scapegoats for Russia's problems in other countries:

And what were the Communists to do?... If the USA demanded that they introduce capitalism — or the USA would deliver USSR communists into the hands of the workers — into the hands of the party of workers from workers 'SLAVES,' founded in 1969. And then formed its own government in 1971 (by the dictatorship of the working class)... Igor Verev...

The end of this notice was missing, it was torn off a wall in Moscow near the Filevsky Park metro station in 1996. The author interprets the crises of the 1990s as an invasion of capitalism, and blames none other than America for these disasters. Populist slogans of different parties and political movements target the electorate that cherishes such thoughts. The Communist Party of the Russian Federation speaks with complete conviction in its leaflets:

STOP U.S. MILITARY ADVENTURISM!
DID YOU CALL IN THE ASSASSINS?
In September — October 2006, the Torgau 2006 joint U.S. — Russian exercises are scheduled to take place in the Nizhny Novgorod Region at the Mulino firing range.[30]

30. This joint military exercise was postponed in September 2006 after the Russian Defence Ministry citied undisclosed legal problems.

The Russian Department of Defence assures us that the upcoming exercises are 'innocent' war games. The president of the USA, George Bush, swears to the peace-loving nature of his administration. Mr. Putin remains silent.

We simple Russian citizens have only two options. Option No.1 is to bury our heads in the sand like ostriches, and keep our mouths shut. Option No.2 is to prevent the exercises.

'Easier said than done,' a person with a conscience might say. 'How can you resist the war machine?'

You can, say we.

You can, if you believe that you're the master of the Russian land, and not a guest in it.

You can, if you cherish the memory of your ancestors.

You can, if you unite with the patriots of the country.

You can, if you put the interests of the Fatherland above your personal interests.

You can, if you join your efforts with those of the Russian Communists.

There have been examples in the past. In June, NATO's corporals attempted to land their troops in the Crimea, whose citizens quickly put a stop to the impertinent Rambos. They blocked access to the seaport and kicked the uninvited guest out.

It is your turn now, Russian comrades!

In other words, the enemy never sleeps. And if you don't believe that the enemy exists, you yourself are the enemy. In all fairness I must say that this rhetoric is not the sole prerogative of the Reds. Pro-government political movements indulge in similar maxims. Here is a recent pamphlet dating from March 2007:

President's Liaison

Today, it has been seven years since President Putin took office. Thanks to him: we did not give YUKOS or control over our resources to the Americans; we got back Sakhalin-2; there is peace, stability, and order in the Chechen Republic; law rules the country and not oligarchs; we are not asking the West for handouts anymore; and we don't have to wait for months for our wages and pensions.

The West wants to take away our natural resources — to turn Russia into a colony.

This might happen as a result of the betrayal of some, and the indifference of others.

There have always been traitors. Those who are prepared to hand their country over to the enemy. During the Great Patriotic War, the traitor Vlasov[31] joined the Fascists. He hoped that Hitler would win and that the USSR would collapse. In Russia today there are also

fascists and traitors: Limonov[32] is a fascist and the führer of the
National Bolshevik Party, and Kasyanov[33] promises oil to the West at
a third of the cost, in exchange for help in the struggle for the
presidential seat. Fascists, outcasts, fugitive former oligarchs, pro-
Western liberals, and extremists of all persuasions. They are getting
ready. They are holding rallies, organizing street brawls, advocating
the use of arms and violence, promoting a coup, and calling on the
Americans for help. They want the country on its knees.
This has already happened in Yugoslavia, Iraq, and Georgia.
Now they have become colonies.
You don't believe it? In 1991, most people didn't want to believe that
soon the country would no longer exist. A huge price was paid for this
disbelief: millions of lives lost, destruction, the collapse of the country,
thousands of square kilometers of territory conceded, and national
humiliation.
To avoid this in the future, you must become an active citizen and
stand up for your country. To start with, you should get in touch with
the President's Liaison Information Centre. Every person you meet
today wearing a white jacket and a red baseball cap is a President's
Liaison. You can send an SMS to the President. Or you can become a
President's Liaison yourself by leaving your phone number.
Exchange phone numbers with a President's liaison and become an
active citizen.
Join the OURS team, the President's team.
Protect the country's independence together.
For more information visit www.nashi.su
OURS Democratic Anti-fascist Youth Movement

As you can see, the pamphlet covers it's points in great detail.
In another leaflet, the movement engages in a dialog with the people,
asking rhetorical, but all too familiar, questions of Russian citizens:

WAKE UP! THEY'RE STEALING RUSSIA!
OURS Democratic Anti-fascist Youth Movement
1. What is your opinion about American military bases popping up all
around Russia, and the increasing tensions?
2. Is the policy of the West, particularly the USA, hostile or friendly
towards Russia?

31. Andrei Vlasov was a Soviet Army General during the Great Patriotic War (World War II). After his army was surrounded and forced to surrender, he decided to collaborate with the Germans. He led the Russian Liberation Army unsuccessfully against the Red Army until he was captured at the end of the war. He was executed in 1946.

32. Eduard Limonov founded the National Bolshevik Party in 1991. A writer and political dissident, he was convicted of buying weapons in 2002 and spent nearly two years in prison.

33. Mikhail Kasyanov was the Prime Minister of Russia from 2000 to 2004. Allied with the oligarchs who thrived under his government, he was dismissed by Vladimir Putin along with the entire Russian cabinet in 2004.

3. What, in your opinion, does the West want from Russia?
4. In your view, how can the West weaken Russia and impede its development?
5. In the modern world, the USA resembles a hungry predator that needs more and more food — natural resources. To get them, the USA unleashes wars and occupies foreign countries, such as Iraq. Do you think the USA can completely abandon its plans to seize our resources?
6. In 1941, we were not prepared for war and paid the incredibly high price of 27 million lives to win it. In 1991, we allowed the Soviet Union, a great power, to collapse and turn into a poor country that lost all its dignity. In the 2007 — 2008 elections to the State Duma and the Presidential Elections, we will have to decide whether we want to follow Putin's line for a Strong Russia or to become another natural resource colony for the West. Which do you prefer?
7. Do you agree that if Putin is impeached, or if his policies are not continued, new 'troubled times' will ensue, and extremists and puppets of the West will come to power?
8. Do you rule out the possibility of a coup and intervention on the initiative of the former Prime Minister Kasyanov, for example, under the pretext of inviting NATO's peacemakers to guard nuclear facilities and oil and gas pipelines?
9. What will you do if you learn about a coup or intervention?
10. Do you want to take part in the 'Wake Up! They're Stealing Russia!' campaign and support Putin's line for a STRONG and INDEPENDENT Russia?

Going back to the *Fascists out of the USSR...* notice, in which a simple Russian woman abruptly expounded her political views, it is difficult to deny that the rhetoric of political movements suits the mindset of Russian citizens. In any event, in the Russian fairy-tale world, surrounded by enemies, the politician is transformed into a hero, saving the world from the devil's clutches. He assumes the role of a superior force stamping out global evil. At the same time, he is the creator of a new world where anyone can become the source of evil, or the guilty one.

In the next notice, this role is imposed on the provincial unemployed:

Cleanse Moscow of illegal migrants
Illegal migrants make use of the city's infrastructure free of charge. They take jobs away from Muscovites, since they settle for pennies, and commit at least half the crimes reported in Moscow. Neither those who use cheap imported labour, nor the illegal workers themselves pay any taxes. The marketplaces in Moscow are controlled by criminal gangs backed up by masses of illegal aliens.

ILLEGAL MIGRATION IN NUMBERS

2 – 3 million: this is how many illegal migrants live in Moscow according to experts.

50 percent: over half of the crimes in the capital are committed by illegal migrants.

90 percent: according to the statistics of Police Department officials in Moscow, this is the percentage of working migrants who live in the city illegally.

230,000,000,000 roubles: according the Federal Migration Service of the Russian Federation, this is the amount of financial loss caused by illegal migrants. It is 1.5 times more than Russia spent on education in 2005!

Rodina
[Motherland party notice, 2005]

The destructiveness of this policy lies in the absence of a viewpoint external to itself. The authorities are caught in the gridlock of their own rhetoric, which is a legacy from the murky past.

There is not the shadow of a doubt that such mythologising remains not only a mainstay of political struggle in Russia, but a means of ordering political space. Faith, not rational thought, is what the people need:

We love Moscow, we rely on ourselves, we have faith in Russia!
[United Russia poster, 2003]

Выборы в Московскую городскую Думу

Кандидат в депутаты ПЫРХ ЕЛЕНА

Пырх Елена - начальник отдела по сбору бананов Российско - Африканского предприятия имени Мабуту, член Центрального совета народов Африки.

Пырх Е. родилась в рабочей семье и уже с детства училась лазить по деревьям. Работать на завод пошла, с 17 лет, училась в школе рабочей молодежи N239, затем окончила институт Дружбы народов имени Лумумбы. Всего за год работы прошла славный путь от простого бананоочистителя до сборщицы столь нужного стране продукта и в 1996 году была избрана начальником отдела. Защитила кандидатскую диссертацию. За время работы на предприятии ею были опубликованы научные работы на темы "Роль банана в жизни народов Севера", "Технология очистки бананов" и многие другие, получены авторские свидетельства на изобретения, созданы уникальные экспериментальные стенды.

В 1997 году вступила на путь политической деятельности. Она принимала участие в создании партии "Народы Африки против обезьян", является одним из ее основателей.

Пырх Е. не замужем. Детей не имеет.

РОССИЙСКОЕ ДВОРЯ...

In the Russian political process, the mocking smear campaign has quickly caught on:

Moscow City Duma Elections
Candidate for deputy: Yelena Pyrkh
Yelena Pyrkh is the head of the Banana Harvesting Department of the Mabutu Russian–African Joint Venture, member of the Central Council of the Peoples of Africa. Mrs. Pyrkh was born into a family of workers, and already in her early childhood she learned how to climb trees... In 1997, she embarked on a political career. She played an active role in the creation of the Peoples of Africa against Monkeys...

No portrait of the Russian political scene would be complete without a notice from the supporters of monarchy:

The Russian Assembly of the Nobility
121019 Moscow
Maly Znamensky per. 5
Phone: 203-01-23

Gentlemen,
On 17th December 1996, at 7:15 p.m., in the dining room of the Assembly of the Nobility, the Counsellor for the Embassy of the Kingdom of Sweden will speak on the subject of 'Monarchy, Nobility, and Democracy in Modern Swedish Society.'
All members of the Russian Assembly of the Nobility are invited.

Department of International Relations
Department of Special Tasks

It's great that the Russian Assembly of Nobility has a Department of Special Tasks. There might not be an Emperor, but there are special tasks. As a film character played by Rolan Bykov[34] says: 'There was no earthquake, but there are victims!'

34. Roland Bykov was one of the foremost figures in Soviet and Russian film. He was an actor, director, and script writer.

Уважаемые соседи!
кв. 41

Хотели Вас уведомить,
что если еще раз повто-
рится такой концерт
как сегодня, то мы
будем вынуждены без
предупреждения вызвать
наряд милиции для
установления порядка
1 октября 2005,
2 часа ночи
Жильцы 5 эт.
Больше нет сил
терпеть это безобразие!

TIMES AND CUSTOMS
Pasha, you're a fucking moron!

The next group of notices describes Russian manners and customs. It consists of messages from citizens to one another expressing various requests, demands, even threats. I discovered this notice on the door of my own apartment:

Dear neighbours in apt. 41. We would like to inform you that if you continue with concerts like today's, we will be forced to call the police without warning to restore order. 1st October 2005. 2 a.m. Residents of the 5th floor. It's an outrage!

This memo was composed by an alcoholic living below me, when I stopped 'lending' him drinking money.

Very often, communications between citizens display clear signs of meddling in other people's private affairs:

To the residents who systematically knock their bed against the wall morning and evening (between 8 and 9 o'clock). With all due respect: give it a rest! Thank you. Your neighbours.

НОСИТЕ <u>ЦЕННЫЕ</u>
ВЕ<u>ЩИ</u> с собой!

администрация

While we are on the subject of Russian morals, we cannot omit theft:

Brothers and sisters! Taking video and audio tapes from the tables and shelves without blessing is a sin — a transgression of the eighth commandment: Thou shalt not steal.

Anything can be stolen here: memorials from cemeteries, high-tension wires, and even entire corporations, if necessary. The following notice was hanging in a shop where a cash machine had once stood:

Please return the ATM bank terminal for a reward. The Management.

Generally, the situation does not favour humane treatment of the perpetrators:

To thieves: We cannot be held responsible for damage and injury you might sustain upon breaking into this club! Signed: the club's teenagers.

To avoid falling victim to theft, you should take heed of the following saying: All that's mine I carry with me. Translated into the language of signs this reads as:

Keep your valuables with you at all times! The Management.

Citizens sometimes have to resort to writing notices addressed to those who steal notices:

Whoever stole the notice about the stolen rubber mat, please return it, or else this sin will burden your conscience until the end of your days!

In Russia's prevailing poverty, even an old invalid's walking cane may be filched:

If you picked up the walking cane left by the door, please return it to Apt. 21.

Poor people's notices are a topic for a book in their own right:

Peepl! I hav a request for you. I just did my term. I was on my way home. Stray dogs atacked me. I'm hungry. Pleez help me out if you can.[35]

Announcements with the express goal of keeping citizens within the limits of reasonable behaviour at social events reveal a perfect synopsis of Russian mores:

Rules of the Disco
Boys: when asking a girl to dance, don't grab her by the hand and shout 'Hey, you! Let's dance!'
Girls: don't sniff and blow smoke in your partner's face from your nose and ears!
Don't dance barefoot with handbags and other people's girls.
Before pushing, apologise, preferably in writing, and file two copies.
If a girl turns you down for a dance, thank her in complete sentences, not rude expressions.
Pick a girl with your eyes, not your hands.
Lead the girl to the dance floor by her hand, not her neck.
Don't go from one girl to another stomping on their feet.

Here is a unique Soviet notice from the 1970s:

Behaviour rules at dances. The labouring class should come to dances wearing light clothing and shoes. It is prohibited to dance in uniforms and sporting attire. Distorting the form of the dance is also strictly prohibited. The dancer should execute the steps correctly and precisely, moving your left and your right feet with equal dexterity. The woman has the right to express in a polite manner her displeasure if her partner violates the established distance of five centimeters between dancing partners, and she may courteously request his excuses. Smoking and laughing should be limited to specially designated areas. The Management.[36]

Russian entertainment announcements add a special touch to this image of civilian life. They are clearly witness to the reign of widespread poverty:

To everybody! If you want to have a good time, come to the New Year's Party 1999. There will be a buffet, dancing, and New Year's entertainment. The party begins at 3:00 p.m. local time on 26th December. Bring your own CUP, FORK, GLASS, PLATE, and a READY MEAL. Entrance by invitation.[37]

35. Olga Florensky, *The Psychology of Everyday Typefaces*, St. Petersburg. 2001.
36. Found by N. Sizov.
37. Found at the gates of Gusinoe Ozero Military Base, Buryatia. New Year's Eve 1999, by A. Gonotkov.

An announcement in the Aleksandrovsky Park in central St. Petersburg chronicles in great detail the most common misdeeds of those seeking to spend their leisure time there:

Park Rules:
The following are not advisable and strictly prohibited: to consume strong alcoholic beverages; to stand on the park benches; to harass others; to sing loudly and boisterously; to walk dogs; to catch birds and squirrels; to walk on the grass, to cut down trees; to lie on the asphalt; to litter the park.
In short, the park grounds are guarded round the clock!

Birds and squirrels might make pets or meals. Here are a few more notices that characterise people's treatment of animals:

Don't knock on the glass! The animals ain't dead.
They're just sleeping.

In a zoo's reptile house, pasted to the glass:

Don't knock. They won't let you in.

Then there is the classic:

Warning! Do not offer alcoholic beverages to the bear!
Fine 1,000 roubles!

Sometimes, members of the public exhibit unsound behaviour, and the management of entertainment establishments must introduce rules and prohibitions to protect the health and safety of these very citizens:

Caution! Dear friends, Beginning on the 20th April we will STRICTLY FORBID the use of the racetrack while intoxicated. We consider the following substances to be incompatible with go-kart racing when used in large quantities: alcohol, weed, cacti, and other magic potions.

If in doubt about the state of a client, the manager of the track will make the decision to allow or disallow them from using the go-kart by gazing into the client's honest eyes. The manager's decision is final and cannot be disputed or overturned! If the client has been admitted to the racetrack but has begun to behave inappropriately during the race (like it kicked-in while he was at the wheel), he may be disqualified from the race at any moment at the discretion of the manager. The decision to refund the client for using the racetrack rests with the manager and depends on the time spent on the track and the amount of damage caused (if any).

Remember! As a private company we do not need to justify our personal decisions. Arguing with the management by boasting about your skills and the achievements you have made on the ring road and

other streets in the city is pointless. This rule is being enforced to protect your health, the safety of the racetrack's employees, and the integrity of the equipment.

Thank you in advance for your understanding.

The management. WayMart Go-Karting Club.

The authorities punish their citizens in all kinds of ways for not adhering to the rules:

Warning! The management of sanatorium hereby informs you of the undignified behaviour of patient Vladimir Romashkin (born 1955) an arc welder, who arrived on 20th March 2005.

During his stay he was repeatedly found in a state of extreme intoxication. He disturbed his neighbour and left his room in an unsanitary state. He pissed on the bed. An official complaint has been lodged against him for destruction of property, and he will be made to pay for damages. For noncompliance with the rules of the sanatorium, Mr. Romashkin was prematurely expelled and his place of employment has been alerted.

30th March 2005. The Management.

The texts of these announcements clearly demonstrate that nothing has changed in the relationship between the authorities and the citizens since Soviet times. The number of prohibitions and repressive measures in any given social space can be very large. They suggest a very dense social fabric and often allude to completely outrageous patterns of behaviour on the part of citizens:

There is a 1,000 rouble fine for defecating outside the specially designated areas.

On top of the sign was written:

Your ad goes here.

Notices calling for clean, neat surroundings complete the picture:

Citizens! Don't throw rubbish under the window!

Or:

Dear residents, Please do not throw refuse and cigarette butts out of windows. They land on other people's balconies and window ledges. Respect others!

Sometimes, these notices turn into threats:

Attention!
Dump your rubbish here and I'll punch you out.

Here is another one that is anything but a model of politeness:

Moron! Stop leaving rubbish bags here. I'll track you down and you'll regret it! The bins are just twenty steps from the entrance.
With contempt for you.
Signed, a fellow resident.

Because there are no special areas for walking dogs, many notices address the subject of our four-footed friends, as well as more general filth found in our cities:

Dear Doggy, please poop with your owner somewhere else.

Another example reads:

Dogs! Don't allow YOUR OWNERS TO EMPTY THEIR BOWELS in the courtyard![38]

This leads us directly into the realm of profanity and invective. The following message reaches the heights of courteousness:

Pasha, you're a fucking moron! Go smoke a cap! Arsehole! Dickhead! Motherfucker! You prick! And your bitch is a slut! Fucking queer! Fuck you, you cocksucker! Love from the whole second year class!

(To *smoke a cap* refers to the act of oral sex — a *cap* is the head of the penis).

Our beautiful language, full of vibrant and colorful obscenities may still be heard on every street corner.

38. Found by Anna Karatygina.

LOVE LETTERS

Will fuck in the arse on Fridays. Women need not reply.

Declarations of love often take the form of graffiti, but among simple notices there are also some true gems. The texts are usually anonymous and have no addressee:

Love you!

Cases in which the addressee is named are far rarer:

Oleg, you will always be mine! 15th February 1993

Or:

Lena, I love you!

One can assume that fixation on love itself bears a somewhat ritual character. It elevates love to a new status, putting the stamp of eternity on it. It is well known that men often tattoo the names of their beloved women on their bodies (usually on their chests and arms). In the eyes of women these tattoos are proof of the depth and sincerity of their partners' feelings. Thus, affixing the name of the lover on the body, on a marriage certificate, or on a street wall are all ways of legitimising relationships.

Love letters are most often encountered around entrances to residential buildings. They generally feature little hearts and names written inside hearts. The traditional formula of a love spell postulates the merging or blending of hearts: 'may the heart of (woman's name), servant of God, adhere to and mingle with the heart of (man's name), servant of God, and be one...'[39] One of the most widespread patterns for declarations of love in graffiti is A + B = *love*. This is not only a declaration of love — the message of love may also be equated by the author to an event or a fact of life — these are words with the power to transform life. Making up texts about love is perceived as 'making' love. The depictions of hearts pierced by an arrow, hearts connected with the plus sign, and hearts pictured within hearts, are all synonymous to A + B = *love*. Let us not forget that traditional love spells are still common in urban culture: 'even today, in Moscow... love spells and magic... are very widespread...'[40] The scholar cites examples of spells that are common in student circles: 'You light up a cigarette, take a drag and say, *O smoke, king of smoke... Fulfill my wish* (take a drag), *charm* (name), *servant of God... So that my word is harder than rock* (take a drag). *Amen* (take a drag). *Amen* (take a drag). *Amen...*'[41]

39. A. Toporkov, *Russian Erotic Folklore*. Moscow, 1995.
40. Yu. Kisileva, *Magic and Superstitions in the Moscow Medical Schools*. Zhivaya starina, 1995. Issue 1.
41. Ibid

The existence of love charms is a fact of contemporary urban life. Of course, it would be incorrect to equate street messages with ritual language. In such cases, we are sometimes dealing with extra-ritual usages of ritual formulae. But while the function of the text might change, its semantic link to the ritual is preserved. These are texts that act upon the love object.

Let me cite another 'love' message, composed in the genre of 'letter writing' common in folklore, which demonstrates how complex and far removed from simple reality and ordinary information these texts are. It was written in marker pen on the wall of a building:

Fuck with me
Remember how
We found
A condem
in the rubesh
I fucked you
for 2 days
nonstop
And we panted.
Also remember
We got busted
And your dad
fucked you in the cunt
and the mouth
and the butt
And my dad cut off
his dick and
put it in his
arse reel meen
And then he
couldn't shit
And he blew up
like a baloon.
He blew up
and popped.
And our mothers
were lezbians
and fucked for
3 months
Coz they were all sad
And when they got hungry
They ate up our lil brothers
And sisters.

And then you left
and took our condem
with you.
And I fucked with a pillow
And now Im riting you
this letter.
With love
and
Sex.
Me
Gene. [1996]

Formally, this text conforms to the requirements of the traditional letter genre. It is a memory in verse about lost love. This pornographic 'romance' begins with the exhortation *Fuck with me*, and ends with the formulaic *With love and sex*. The situations described include scenes of anal, oral, and vaginal sex, as well as masturbation (with a pillow), both heterosexual and homosexual acts, incest, castration, cannibalism, and even raping oneself in the anus with one's own penis.[42] In view of the fact that nearly all the basic bodily functions and situations are described in this letter, it might be perceived not simply as an ordinary message, but rather as something more cosmological, initiating the evolution of sexual relations in general. Roughly speaking, this is not a description of sexual acts, but a model of the Universe.

It may be more apt to analyze such notices from the point of view of psychoanalysis:

Mine.
My love
My dear
My sun
My orange kitty
My little mermaid
My hot sun ray
My radiant one
My sweet one
My tender one
My charming one
My bride
My little one
My little clown
My sun beam
My fluffy, tender cloud

42. This motif appears in the folk tale *Fool* by A. Afanasyev, *Russian Folk Tales Not Fit for Print*, *Famous Proverbs and Sayings*. Ladomir, Moscow, 1997. Issue 33

My girl
My treasure
My little witch
My grey-eyed one
My cute one
My ginger-haired one
My little panther
My little one
My silly
My child
My betrothed
My bright one
My little foxy
My little button
My swallow
My bit of fluff.

In this message the author of the text attempts to establish his own 'self' as a subject of love, rather than simply communicating, i.e. informing the object of his love about his feelings. In this elevated apostrophe, the lover repeats the formula of love over and over again. This repetition is obsessive and amplifies the meaning. To the man, it seems that his I is the desiring subject, although in reality it is only a narcissistic object and demands to be symbolically positioned as the good, the necessary, the beloved. Thus, the I desires to become the object of desire, and is not content just to be the one who desires. The man loves the image of himself, which he has misplaced, lost, or banished. We are dealing here with a displaced desire of oneself, or rather, a displaced desire for a displaced self.

Many love letters can be analysed purely from the communicative point of view, as a zone of informal address. This becomes more evident as we examine messages and graffiti within their respective contexts. Here are several messages copied from a tram stop by a metro station in St. Petersburg in 1993. Judging by the dates, the messages had been accumulating over several years:

Waiting for trams 9 and 22.
Vanilla Arse. Sex.
Waiting for tram number 9. Where is it, I ask you? It's cold! Brr-rr-r. The 22 came. 12:21, 26th September 1990.
Well, and where's the 9, huh?! We've been standing here freezing since 12:00! 26th April 1993.
We're not waiting for anything, just smoking and having fun. Maestro. Sh. the bassist. A. the keyboardist.
Waiting for the 9 and melting from the heat. 2:52 p.m. June 1991.

Will fuck in the arse on Fridays. Women need not reply. 598-11-50. Zenit.[43]

The tram is coming!!!

We're waiting for a number 22. There's three of us. We drew our pictures while we waited, but here comes our tram. Cheers, everyone! 7:48.

We're waiting for the tram. Khokha and Paul.

It's damn cold.? -18°C, and in my house it's only +13. I'd shoot all the drivers and furnace operators, fuck it. 7:25 p.m. 12th December 1989. S. Vans.

We're waiting for the tram. Got sick of waiting, so we're gonna go catch a bus at the bus stop instead. Paul and me.

Sex Pistols. Swine. Punk rock. And we're waiting for a dick that will come tomorrow. A.

SPTU-4.

Zenit.

Writings.

Hurray! The tram is here!

Dick for sale 550-02-62.

1:10 p.m. Cold. No trams.

Zenit.

We're waiting for the tram. It's not raining. 6:20 p.m.

2nd March 1992. Olga.

We're waiting for tram number 47. 2nd December 1987. Natasha, Lena, Zhenya. PTU-113.[44]

Some dubious announcements demonstrate a desire to find sexual partners:

Will rent a tart. Phone…

Or:

Will rent a girl for myself in this neighbourhood without intermediaries.

This is actually a play on a very common type of notice that reads, Will rent a room/apartment for myself in this neighbourhood without intermediaries. Here intermediary implies an estate agent; on the sign above a pimp. I'm sure estate agents everywhere would have something to say about the correlation of these jobs by the notice's author.

43. Zenit is the name of a local St. Petersburg football team.
44. SPTU and PTU are abbreviations for technical schools.

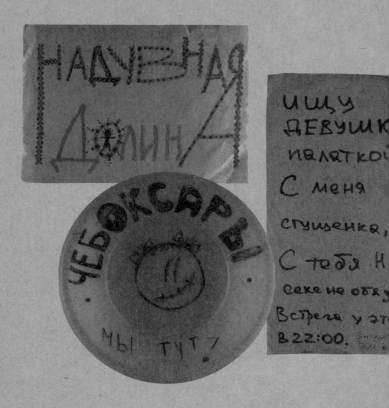

The next announcement was posted at the rural Blow-up Valley Festival near Moscow in 2005. This kind of love notice is quite common at such gatherings:

Looking for a girl with a tent
Will provide canned meat and massage
You should bring hope; sex is not obligatory.
Meet me by this message board at 10:00 p.m.
I look a lot better than I write!

The same message board had a note written on a yellow plastic plate:

Cheboskary. We're here.

Right next to it was an announcement promising happiness:

Stage 3
10th June
Aeroglyph
The Light Rock Orchestra
Elephants and happiness will be distributed

Notices concerning sexual services overlap with the topic of love. Prostitution flourishes as never before. On the black market one can buy and sell anything, from Moldavian concubines to Uzbek slaves. The parliamentarian Yelena Mizulina, described Russian slave trading in 2003: 'It is exploitation of slave labour, indentured servitude, serfdom, and recruitment of people with the goal of exploiting them in various ways, including sexually, all rolled into one.' Classified ad sections of newspapers and the internet are jammed with offers of sexual services. In this book I will touch on the topic only briefly, as the information is widely available in cyberspace. These ads can be veiled and ambiguous. Often they offer high-paying jobs to girls:

High-paying job for slender girls with no problems.

According to the Institute for Social and Economic Research, around five million Russians sell their bodies, both at home and abroad.

Sex service ads began to appear in newspapers and on streets in the early 1990s. The easy accessibility of these services was a novelty:

Attention! First time in the city! Yevgenia, young, interesting girl, offers services of an intimate nature to men between 30 and 60 years old. Quality and confidentiality guaranteed!

Nowadays, these notices are no longer so amateurish. The infrastructure has been established, delectable pictures of the girls are made my professional photographers, and the texts of ads are distinguished by a flamboyant style. At the dawn of Russian capitalism, however, these ads were more simplistic and to the point:

Irene. Cheap n' quick.

AUTOGRAPHS AND PRAYERS
What are you staring at? Fuck off!

Another type of notice is the so-called autograph. It may be, for example, the name of the writer of the notice, or a short inscription, which initially appears to be meaningless.

In traditional folk culture, the written word is sacred and eternal, and it is addressed to God. Here verbosity is superfluous, a single name, a single cross is sufficient. This was articulated quite simply and originally by A. Medyntseva:[45] 'Numerous depictions of the cross without accompanying inscriptions... are also prayers...' So a simple and undistinguished event in the life of an ordinary person, written on a piece of paper and then attached to a wall on the street, (that is, on the 'body of the world') becomes a fact of divine history. Messages such as 'so-and-so did such-and-such' or 'so-and-so was here' (for example, 'Kilroy was here') are generated by the wish to chronicle an event in one's life on the tablet of sacred existence: 'Some inscriptions have a special historical value, as they contain information that did not capture the attention of the chroniclers.'[46] These become 'inscriptions that augment the chronicles.' It is not surprising that there are a great number of contemporary notices devoted to historical events.

The 'autograph' can be viewed as a signature to one's own life, as a message to God. This signature contains the author's *I* in a compressed form. In this sense, a mirroring, self-identification is present. It is as if the *word* is equivalent to the *person*. This message contains an element of sacredness in it — as in the word that 'was in the Beginning.' These messages are numerous, but are often overlooked.

45. A. Medyntseva, *Ancient Russian Inscriptions in the Novgorod Cathedral of St. Sofia*. Moscow, 1978.
46. Ibid.

So far we have considered popular messages as the 'voice of man,' as an utterance. However, they can sometimes be, 'the voice of things.' Analysing inscriptions on Greek vases for the first time, N. Braginskaya called attention to this phenomenon: 'Inscriptions in general, and inscriptions on vases in particular, are akin to oral utterances. They are *vox rei*, the voice of a thing.'[47] In this context, it is not entirely correct to speak of 'needs, desires, and feelings' of human beings, and to study stereotypes of behaviour using such texts as evidence. One should rather speak of the magical nature of things, and the ritual, unconditional, and not altogether Christian perception of these objects. The thing itself comes to life. Modern Russian street messages offer rich material for testing such assumptions. The classic messages on vehicles (*Hit the brakes, Watch it!*) or walls of buildings (*Move on, Fuck you!*) are related to these. Bathroom-mirror scribblings, such as *You're ugly* or *What are you staring at?*, are common. A connection between these messages and the 'magical' perception of objects is plausible.

47. N. Braginskaya, *Inscriptions and Depictions on Greek Vases, Culture and Art of the Ancient World*, Materials from the Pushkin Museum of Art National Conference. Moscow, 1980.

ENTRANCE HALL:
A HOUSE OF PRAYER OR A HOUSE OF SIN?
I'll kick your teeth out one by one, arsehole!

Entrance halls in Russian urban culture are traditionally places for drinking spirits, doing drugs, having sex, relaxing, sleeping, and many other activities. As a consequence, the tempestuous life of these spaces leaves picturesque traces. The state of these spaces is summed up in graphic detail in the following notice from a residential building:

Dear residents,
The management of the Perm Housing Committee would like to inform you that some insane and dirty people living among us are robbing our homes.
They steal light bulbs and locks from hallways.
They take out glass panes in doors and windows for their own use.
They stole glass from doors 16 and 11, and window panes from the 10th floor.
Now they have stolen glass from a door on the 12th floor.
They write obscenities and spit on ceilings and walls.
They write all over the lifts and vandalize them.
They pile up litter, boxes, milk cartons, and glass bottles around the rubbish chute.
Why do you tolerate all this?
Do we really have to live in a Trashed, Saliva-ridden, Urine-covered house?
It is our duty to take measures against this.
The Management

The attitude of the residents themselves toward the frenetic vandalism is hardly tolerant:

Dear guests of our entrance hall,
If you have come to visit someone in particular, make sure you know exactly where your friends live and ring THEIR doorbell. The residents will, of course, be only too happy to give you a hint about where you should go when you come calling at midnight, but it is generally advisable to know the floor and apartment number of your friends in advance to avoid misunderstanding.
If you have come on a short unofficial visit (to answer a call of nature, for example), you must have on your person:
1. Your passport
2. An expensive watch
3. Your mobile phone
4. A chequebook to pay for damage to the entrance
5. A pair of crutches
6. Iodine
7. Cotton swabs
8. Bandages
9. A pound of powder for a plaster cast
10. Your last will and testament
Residents and guests, remember: it is better to stay in one piece without a light bulb, than to be an invalid with one. Moreover, if you get caught stealing a light bulb, you'll be surprised to learn which parts of your body can be used as a socket.
Welcome to our entrance hall!

Most of the time, these messages are noteworthy for their aggressiveness:

A note to whoever is stealing the light bulb:
I'll kick your teeth out one by one, arsehole!
Floor Manager

The following quote describes what residents might have delivered along with their post in the mornings:

Gentlemen junkies, please do not throw used syringes and other paraphernalia through the letter boxes!

Sometimes, conscientious residents scold their neighbours for inappropriate behaviour:

Dear neighbours, be considerate! If you take the junk out of your apartment, finish the job and take it out of the entrance hall!

These unofficial notices bear stark contrast to the radiantly happy and polite goodwill of official ones:

Comrade! Keep your home beautiful. This is where you live. Build a fence and give it a fresh coat of paint, and this will bring you joy!

This reminds me of an warning text from the Soviet era:

*Women, remember: a good home life ensures your husband's success
on the production line.*[48]

Wall messages and inscriptions confer a certain status on each individual
entrance hall. Sometimes an they begin to function as hallowed space.
In some, drug addicts smoke their magic weed and idolise their
Rastafarian gods. In others, fans of the band Kino perform rituals of
worship for their dead hero, Victor Tsoi.[49] In still others, hippies
contemplate the vanity of all existence and the infinity of the Buddha.
Among these is the St. Petersburg Rotonda. Here the messages and
graffiti on the walls transports visitors across into the other world:

*Forget the world outside, when you come here. Abandon all hope,
ye who enter here.*

When Victor Toporov[50] studied the Rotonda texts, he was above all
interested in the sacred writings. He notes that 'the majority of the
inscriptions reflect... the search for God, faith, truth.' This search
continues beyond the boundaries of the walls:

*Guys, everyone who wrote something here. Let's get together on
11th Nov, 1986 at 11 p.m. and talk. I think we have a lot to discuss!*

The thousands of entranceways that are thickly covered in drawings and
messages perform an important social function. They transform the
modern urban space, turning the most ordinary and insignificant corners
of the city interior into hubs of social life, textually organizing extra-social
fields of existence.

48. From the collection of Z. Yachina.
49. Victor Tsoi was the lead singer and creative force behind Russia's most popular native rock band,
Kino. He died tragically in a car crash in 1990 at the age of twenty-eight.
50. V. Toporov, *Petersburg Texts and Petersburg Myths, Festschrift for the 70th Anniversary of Prof.
Yu. Lotman.* Tartu, 1992.

LIVING GODS AND HORNED DEMONS

Maria Devi Christos is a fucking dirty cunt.

Ads of a religious character are usually distinguished by their simplicity:

Brothers and sisters,
The Parish Council of St. Seraphim Sarovsky Church in Kuntsev
invites you to worship at mass and to take part in a procession on
15th January at 1:30 p.m.

They often reproach lax parishioners who flout the most elementary rules of behaviour in the church:

It is prohibited to talk or pace the floor during services.

It is possible to derive a detailed portrait of the modern Russian parishioner from such notices:

Warning! It is a sin to kiss holy icons while intoxicated! If you do so,
it will incur the wrath of God!

A large number of swindlers speculate on the emotionally charged faith of believers and post ads such as the following:

Do you want to talk to God? Call 916-70-09. God.

The next ad seems to fall into the same category:

Will consecrate automobiles:
Russian make — 50 rbls.
Foreign make — 100 rbls.
SUVs — 150 rbls.
GUARANTEED.

This sign was held by a man wearing a cassock standing at the side of the road. I hope that more orthodox priests do not engage in this sort of commercial activity. Sometimes even God can't intervene to help Christian businesses:

The shop is closed until 15th October for reasons beyond our control.
Church Management.

Some of their wares might seem a little surprising:

Dear customers, the Mercy Shop offers a broad range of beer, spirits,
and tobacco.[51]

In the late 1990s, I was quite astonished to see a notice offering car repair services for high-end foreign models in the cellars of the Church of Christ Our Savior, in Moscow.

51. From the collection of Andrey Gavrilin.

МАГАЗИН

ЗАКРЫТ ДО 15 ОКТЯБРЯ

ПО ТЕХНИЧЕСКИМ ПРИЧИНАМ

Администрация Храма

The following street banner hanging over a motorway in the Severny District of Voronezh, known for its high rate of car accidents, adds anxiety to ambiguity:

Jesus is waiting for you!°

Besides the Russian Orthodox faith, religious fanaticism and fundamentalism of every kind are rife in the former USSR. The numbers of sects, gurus, magicians, and spiritual leaders are growing rapidly. It all began very innocently with a certain Anatoly Kashpirovsky[52] who, as he himself claimed, 'came to resurrect':

Anatoly Kashpirovsky in 'I Came to Resurrect the Living.'
Thanks to the scientific discovery and philosophy of the world-renowned doctor and psychotherapist Anatoly Kashpirovsky, millions of people have been healed.
Today, you will participate in a unique event.
The Baku Cinema...

52. Anatoly Kashpirovsky was a psychotherapist who, after he was shown working with his patients on Soviet television in 1989, became one of Russia's most famous faith healers.

After Kashpirovsky, Maria Devi Christos[53] entered the religious scene. She exhorted her followers to repent before Judgment Day, which, according to one of the most uncompromising ads I've seen, should have taken place on 24th November 1993:

Brothers and sisters! The Lord is in our midst! Maria Devi Christos, the Mother of the World! Repent your sins, for time is growing short. Judgment Day is coming on 24th November 1993.
Maria Devi Christos, the Mother of the World!
Saviour and comforter
Messiah on Earth
Only she can save you. Without her, you will die a gruesome death from the Antichrist. She will give you, people, your last chance for salvation. Whoever does not accept her with his heart and repent for his sins, will go to HELL! Whoever worships Satan, who has already come into power and walks the Earth under the name Emanuel, will go to to HELL! Do not accept his monetary system, which is 666 (personal code in the unified computer financial credit system in the form of cards and radiant insignia on his wrists and forehead). REMEMBER! Only Maria Devi Christos, the Mother of the World, can save your soul and protect you from Emanuel.

The Museum of Ads and Announcements has an entire range of fliers about this 'living goddess.' The most peculiar contains the full genealogy of Maria. The text is titled *The Evolution of Human Kind of the Biblical Era*. A brief enumeration (but not the complete family tree) follows:

Ein Sof, the Unrevealed God — Adam — Seth — Noah — Shem — Abraham — Jacob — Isaac — Joseph — Prophet Aaron — Moses — Priest Elisarius — Joshua — Twelve Tribes of Israel — Prophet Eli — Prophet Isaiah — Prophet Ezekiel — Prophet Jeremiah — Prophet Daniel — The Twelve Prophets — Joseph — Virgin Mary — John the Baptist — Jesus Christ — Peter — Judas — Prince Vladimir — Princess Olga — Prince Igor — Murderer of Prince Igor — Natalia Goncharova — Alexander Pushkin — d'Anthès — Madam Blavatsky — Saint-Germain — Yelena Roerich — Maria Devi Christos, the Revealed God...

An astonishing mixture of Russian culture, theosophy, Christianity, magic, Judaism, adventurism, and unadulterated nonsense, this is probably the most radical example of a text in which, to paraphrase Gershom Scholem,[54] Jewish mystical monotheism degenerates into myth-making and popular pagan magic.

53. Maria Devi Christos established a new religious movement 'The Great White Brotherhood' in 1990, which became very prominent in post-Soviet Union Russia. After coming into conflict with the Russian Orthodox Church it was outlawed, Christos and her husband (John-Peter II) were subsequently jailed for four years.
54. One of the founders of the modern study of the Kabbalah, Gershom Scholem's book *On the Kabbalah and It's Symbolism* (1965) explained the complexities of Jewish mysticism to non-Jews.

БРАТЬЯ И СЕСТРЫ !
ГОСПОДЬ НА ЗЕМЛЕ !
МАТЕРЬ МИРА
МАРИЯ ДЭВИ ХРИСТОС !
ПОКАЙТЕСЬ В ГРЕХАХ СВОИХ, ИБО ВРЕМЕНИ У ВАС ОСТАЛОСЬ СОВСЕМ МАЛО.

СТРАШНЫЙ СУД ПРОИЗОЙДЕТ
24 НОЯБРЯ 1993 ГОДА
МАТЕРЬ МИРА
МАРИЯ ДЭВИ ХРИСТОС
СПАСИТЕЛЬ И УТЕШИТЕЛЬ
МЕССИЯ НА ЗЕМЛЕ

ТОЛЬКО ОНА ВАС СПАСЕТ. БЕЗ НЕЕ МУЧИТЕЛЬНАЯ СМЕРТЬ ОТ АНТИХРИСТА. ОНА ДАЕТ ВАМ, ЛЮДИ, ПОСЛЕДНИЙ ШАНС НА СПАСЕНИЕ. КТО НЕ ПРИМЕТ ЕЕ СВОИМ СЕРДЦЕМ И НЕ ПОКАЕТСЯ В СВОИХ ГРЕХАХ-ПОПАДЕТ В АД !
КТО ПОКЛОНИТСЯ САТАНЕ, КОТОРЫЙ УЖЕ ВОШЕЛ В ПОЛНУЮ СИЛУ И ХОДИТ ПО ЗЕМЛЕ ПОД ИМЕНЕМ ЭММАНУИЛ ТОТ ПОПАДЕТ В АД !

НЕ ПРИМИТЕ ЕГО ДЕНЕЖНУЮ СИСТЕМУ 666 (ЛИЧНЫЙ КОД В ЕДИНОЙ КОМПЬЮТЕРНОЙ КРЕДИТНО ДЕНЕЖНОЙ СИСТЕМЕ В ВИДЕ КАРТОЧЕК, ЛУЧЕВЫХ ЗНАКОВ НА ЗАПЯСТЬЕ И ЧЕЛОВ.

ПОМНИТЕ !
ТОЛЬКО МАТЕРЬ МИРА МАРИЯ ДЭВИ ХРИСТОС
СПАСЕТ ВАШИ ДУШИ ... ЗАЩИТИТ ОТ ЭММАНУИЛА

The real name of Maria Devi Christos is Marina Tsvigun. She was born in 1960 in Donetsk, Ukraine. A journalist, she graduated from the School of Journalism at Kiev University. She was a leader in the Komsomol (Communist Youth Organization), an instructor at the Municipal Council of the Komsomol in Donetsk, deputy of the Denepropetrovsk Municipal Council, and head of the Commission on Press and Glasnost. She was a member of the Communist Party and the Union of Journalists in Ukraine. An attractive woman, she had very liberal sexual leanings. According to Public Prosecutor V. Shokin, 'The investigation indeed had a medical report stating that Marina survived clinical death after her tenth abortion in 1990.' After the collapse of the Soviet Union, she married Yury Krivonogov in 1993 and joined his White Brotherhood. She was then proclaimed the Living Goddess of the White Brotherhood, the Mother of the World, Maria Devi Christos. On 10th November 1993, her crucifixion, along with the subsequent resurrection, was scheduled to take place in Kiev's Sofia Square. She later married a man called Kovalchuk, whom she refers to as Lord John Peter the Second. She calls her followers *apostles*, *fathers*, and *deacons*.

ПЕТЕРБУРЖЦЫ !

Очередной «рогатый» бес наведался к нам в город. И будет улюлюканьем под бубен и обезьяньими ужимками охмурять ваши умы! Сколько еще их будет: *Виссарионов, Шри-Матаджи, М нов*! Неужели всем поклонитесь, включая и самого *сатану Эммануила*?

Знайте! Божьих Овец гонят «сильные» мира сего, где правят деньги и ложь, а бесноватых типа *шамана Оюн-Батыра* приветствуют, представляют им залы и сцены городов. Они готовят путь самому мучителю Эммануилу, зомбируя посетителей.

Возрадуйтесь!

ЖИВОЙ БОГ, МАРИЯ ДЭВИ ХРИСТОС ходит по Земле! Она ваше спасение от бесов! Воздайте же славу **ЖИВОМУ БОГУ**. Взывайте в покаянии и молитве к Имени новому, будете спасены в судный день 24 ноября сего года.

In one of her proclamations, Marina Tsvigun summed up succinctly all the other false prophets and messiahs:

Citizens of St. Petersburg! Yet another 'horned devil' has come to call on our city. He will corrupt your minds with howling, banging of tambourines, and ape-like grimacing! More Vissarions, Sri-Matajis, and Moons[55] will follow. Will you worship them all, including Emanuel — Satan himself? Take heed: the strong of this world, which is governed by deception and money, persecute the Lord's Lambs and welcome the demonic shaman Oyun-Batyr,[56] and they offer them public forums. They are paving the way for the tormentor Emanuel, turning the spectators into zombies. Rejoice! THE LIVING GODDESS, MARIA DEVI CHRISTOS is among us on Earth! She is your salvation from demons. All hail to the LIVING GODDESS. Direct your prayers and repent to the New Name, and you will be saved on Judgment Day on the 24th November this year.

Her rivals are characterised chiefly as *devils* and *demonic tormentors*, who *confuse* and turn *spectators into zombies*.

55. Names of various cult leaders.
56. The self-proclaimed Supreme Shaman of Siberia.

It is no coincidence that the 1990s was the peak of activity for these 'messiahs'. After the collapse of the USSR people lost faith in their former ideals, and there was a period of great ideological crisis. This is precisely the reason that Maria directed her messages not to single followers, but to entire social groups. These 'messiahs' understood perfectly well that they were filling a social chasm that had opened up following the collapse of the paternalistic state:

Cossacks!
Come to your senses! They are manipulating you, trying to lead you into battle against the White Brotherhood!
This is exactly what happened 2,000 years ago, when they drove Jesus Christ and the apostles from the Temples, because they told the truth exposing the rotten scribes and Pharisees. Just as sinners and traitors of the Living God talked people into persecuting and killing Christians at that time, so now sinners and those who have gone astray in black cassocks bless you for attacking the Church of the Living Goddess Maria Devi Christos. Just look at their lives and souls — they are filthy! They do not turn away from pleasure or idleness — they only indulge in riches that murder the spirit. The Lord came to his Mother, MARIA DEVI CHRISTOS, and just like 2,000 years ago, he was not recognised and was being persecuted. Do not become pawns in the hands of Satan Emanuel, who is ruling your churches in secret and will soon assume the position of the ruler of Russia. The Living Goddess MARIA DEVI CHRISTOS will not forgive the persecution and torture of her children. On 24th November 1993, the day of retribution for the detractors and persecutors will dawn.
Living Church of MARIA DEVI CHRISTOS

АНАТОЛИЙ
КАШПИРОВСКИЙ

В ПРОГРАММЕ
Я ПРИШЕЛ
ВОСКРЕШАТЬ ЖИВЫХ

БЛАГОДАРЯ НАУЧНОМУ ОТКРЫТИЮ И ФИЛОСОФИИ
ВСЕМИРНО ИЗВЕСТНОГО ВРАЧА - ПСИХОТЕРАПЕВТА

АНАТОЛИЯ КАШПИРОВСКОГО

ИСЦЕЛИЛИСЬ МИЛЛИОНЫ ЛЮДЕЙ

СЕГОДНЯ ВЫ - УЧАСТНИКИ УНИКАЛЬНОЙ ВСТРЕЧИ

КИНОТЕАТР « БАКУ »
ул.УСИЕВИЧА, Д.12/14
ПРОЕЗД : ст. м «АЭРОПОРТ»

школа **Астрологии**

объявляет очередной прием на 3х годичный курс обучения

справки по тел. ежедн. с 9⁰⁰ до 23⁰⁰

272-01-35

The constant opposition to the Russian Orthodox Church that echoes
through these messages is not simply gratuitous. The leaders of all of
these religious sects understood that it was their primary competitor in
the struggle for 'human souls':

RUSSIANS!
Yet again you are being used for unlawful deeds by someone who
remains in the shadows. By proclaiming freedom of the word, the
black-robed priests give their blessing to cossack warriors and other
black-hundredists to persecute and kill the brothers of the Church of the
Living Goddess MARIA DEVI CHRISTOS. At the same time, the media
are brainwashing, physically [illegible]

Even though Maria had plenty of followers, there were other people who
boldly defaced the messages of the 'new messiah':

Maria Devi Christos is a fucking dirty cunt.

Another so called Russian messiah goes by the name Vissarion:

Earthlings! You will be touched by the word of Vissarion, who is the last
testament from the Father in Heaven who sent him. 'And I give you the
Word, which will judge you on the last day.'
19th January 7:00 p.m. Lensovet Palace of Culture. Free admission.
Petrogradskaya metro station.

Vissarion is the alias of Sergey Torop. He was born on 14th January
1961 in Krasnodar. His parents were construction workers. At the age of
seven he moved with his parents to Minusinsk, in the Krasnodar Region.
He served in an army construction battalion, then worked as an electrician.
Later he worked in the Minusinsk Police Department. In May 1990,
Vissarion 'saw the light' and proclaimed himself to be the Messiah. He
now has several thousand followers and is building a settlement at Mount
Sukhaya, in the Krasnodar Region. His church is called The Church of
the Last Testament or The Community of the Unified Faith.

In order to create a more complete picture of the obscurity of religions in Russia during the mid-1990s, I have listed some of the more entertaining titles of their printed material:

Panteleimon, the Supreme Shaman of the North.
Kuzma, the Supreme Shaman of Siberia.
Taisa of the Scythians, Witch.
Altair, Magician and Psychic.
The International Association of Magicians, Magistrate Irina Svetoch, Prophetess and Hypnotist.
Lada the Priestess, Ritual Black Magic.
Argo the Witch.
Elina Lois, the Sorceress.
Prois Occult Healing Centre of Bishop Raphael, permanent member of the Holy Synod of the Russian True Orthodox Church under the leadership of Leonid Prokopiev.
Contact Centre, the Supreme White Magic of Success.
Russian Reika School, The Vladimir Savenkov Centre for Russian Energy Healing.
Salon of Occult Sciences of Master of Higher Magic, Bio-Energy therapist, Mikhail Kars.
Christ the Holy Spirit. Sergey Trubetskoy.
Russian University of Sorcery, Magic, and Healing.
Anna Gamayun's Centre of Good News Prophet, Master of White Black Magic.
Academy of Psychoenergy-Suggestive Sciences and Non-Traditional Technologies of Vladimir Vis, Master of World-Class White and Applied Magic, Psychoenergetic-Suggestion Expert of the Highest Order.
Alina Slobodova's Search for Strength School.
Granny Olya, Master of Magic for Ukraine, Poland and Germany.
Institute of Valeology Cosmic Consciousness of the International Academy of Informatisation.
Cassandre Seraphim, Voodooist and Magician.
Boris Son, the Oriental Sorcerer, Head of the Centre for Applied Extrasensory Knowledge.

Several ersatz-religious organizations, such as the Star Traveler Private School of Parapsychology, claim to have official licenses for their activities:

Star Traveler Private School of Parapsychology
The High Priest of the Llama-Yut, the Tibetan Healer, Llan-Pa invites you to the School of Parapsychology. Fully licensed.
Introductory course free of charge. 264-91-58
The School of Parapsychology will give you not only knowledge, but also health. Classes in Kalininsky, Vyborgsky, and Moskovsky districts

Sometimes, pastors and messiahs are unable to find venues other than circuses for their shows. There they offer the naïve spectator a variety of magic tricks, which they claim to be 'miracles':

Pastor of the Russian Christian Church from the city of Angarsk will preach on 14th, 15th and 16th November. His service will be accompanied by many signs and miracles.
6 p.m. The Circus.[57]

There are enormous number of ads with a pagan-magical slant, in which the reader is offered services in the realm of sorcery and magic:

A unique opportunity once and for all, to become the one and only for your beloved, and to ward off cheating and betrayal with the help of the I. Herman method. If you wish to gain control over a situation, to influence the behaviour of a particular person, or to get rid of serious problems, you can turn to someone who will take care of it in a matter of days. We only take on cases when we are absolutely sure of positive results. Effective remote or long-distance help is also possible.
Call... Guaranteed.

Sect leaders do not hesitate to use popular films as a means of gathering their flocks. A screening of The Matrix is a little incongruous in the context of a Biblical sermon:

The Rostov-on-Don Church of Christ
We would like to invite you to a Christian service
THE MATRIX
Sunday, 23rd January 4:00 p.m. In the programme:
A sermon from the Good Book
Singing
Friendly mingling
The Matrix (the film)
Free admission
The Rostov Municipal National Philharmonic
170 Bolshaya Sadovaya St.[58]

Various Eastern teachings based around Hinduism enjoy great popularity. The idea of reincarnation was popular among Russians in the 1990s. A name such as 'The Institute for Science of Identity,' for example, filled one with optimism:

Reincarnation
The Institute for Science of Identity invites you to video lectures by Chris Butler on the 7th 10th and 14th February at 6:00 p.m.
Address: Express Palace of Culture, 26 Ligovsky Prospekt, Ploshchad Vosstaniya metro station. Free admission

57. From the collection of Alekesy Manturov.
58. From the collection of Artemy Lebedev.

During this period astrological teachings were elevated to an intellectual status (page 165):

The School of Astrology is accepting applications for a three-year programme. For information call 272-01-35 from 9:00 a.m. to 11:00 p.m.

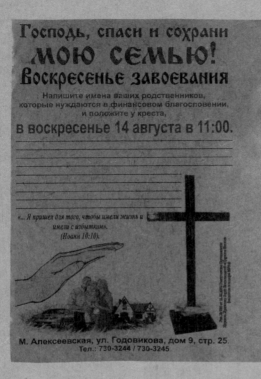

(Nevsky Prospect, St. Petersburg, 1995. The school still functions today and has branches all over Russia. Even the telephone number remains the same).

Many kinds of sect leaders promise people not only access to true faith, but also – if they attend at the right time – the prospect of financial prosperity:

Lord! Save and protect my family!
The Sunday of conquest
Write to me the names of your relatives who need financial blessing and put this by the cross on Sunday, 14th August at 11:00 a.m. 'I have come that they may have life, and have it to the full.' (John 10:10)

The next notice proclaims that the Russian Grail, the whereabouts of which was unknown up until that very moment, had appeared at 9 Pushkinskaya Street, St. Petersburg. It is widely believed that the Grail only materialises in places where the innocent suffer. They say it had appeared at the Solovki Monastery in the beginning of the 20th century and had been entrusted to the Holy Elder Seraphim. The text of this mysterious notice reads:

From 19th June to 2nd July
The Russian Grail
Blood of Martyrs
The golden treasure of the 1st – 20th cent. The Grail in Rus
The Imperial Dynasty
The Na Pushkinskoy Social and Cultural Centre. 9 Pushkinskaya St.
Metro: Ploshchad Vosstaniya, Mayakovskaya

I cannot neglect to mention several masterpieces of the infamous Shoko Asahara:

An Aum Shinrikyo seminar... made possible thanks to the efforts of...
the Truth of His Holiness Teacher Shoko Asahara.
Shoko Asahara
This most profound teaching, based on primordial Buddhism, tantric Buddhism, Himalayan yoga, and Taoism, which coincides with the teachings of Jesus Christ, will help you:
1. Be healed of incurable diseases, decrease stress, and acquire health.
2. Achieve stability of spirit, sleep less, develop willpower, memory, and your powers of concentration.
3. Fulfill your desires and advance in your job.
4. Through persistent practice achieve the Freedom and Enlightenment that many students of the Teacher have already achieved.
. . .

Programme:
Lecture by one of the Teacher's best students.
Training in the methods of Buddhist practices and yoga techniques.
Individual consultations and advice

As we can see, the teaching not only encompasses heavenly goals, but also more earthly ones. The second notice from this sect sounds still stranger in the Russian context, in so far as it incorporates a number of mutually exclusive commercial approaches, simultaneously offering ways of losing weight, becoming more intelligent, acquiring belief in the Buddha, conquering colds, mastering yoga, finding the secret of eternal youth, ridding yourself of all illnesses, learning the philosophy of Taoism, and, on top of all that, gaining access to a true mystical experience by communing with the gods:

Secret techniques of Himalayan yoga
An Aum Shinrikyo seminar, made possible thanks to the efforts of the Spirit of Truth of His Holiness the Teacher
Stages of initiation in the secret techniques of Himalayan yoga
1. Basic breathing techniques of Gayatri Mantra
2. Anuloma Viloma Pranayama
3. Sahita-Kumbhaka Pranayama
4. Hindu Sandali
5. Vayavya-Kumbhaka Pranayama
6. Vayavya-Kumbhaka Pranayama with visualisation
7. Apan-Kriya
8. Bhastrika Pranayama
9. Maha Bandha Mudra
10. Vayavya-Kumbhaka Pranayama of a higher level
Vayavya-Kumbhaka Pranayama

Results:
1) Quick Kundalini awakening;
2) Increasing mental abilities
3) Losing weight, strengthening the body
4) Rejuvenation
5) Conquering chronic colds, drying up mucus
6) Ability to enter Samadhi
7) Acquiring assorted mystical experiences.
Shoko Asahara
Sunday, 3rd October
Palace of Culture, Moscow State University
Metro: Okhotny Ryad
1 Herzen St.
Beginning at 6:00 p.m.
Free admission
Pranayamas and mudras of the higher level
are guaranteed to help you quickly:
— get rid of illnesses;
— achieve happiness in the world;

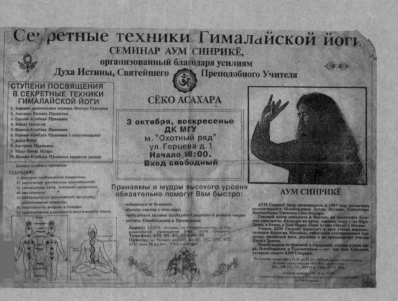

— achieve spiritual awakening (Kundalini awakening and chakra development);
— achieve freedom and Enlightenment.
Address: 125475 Moscow, 32a Petrozavodskaya Street,
preschool No.468, Aum Shinrikyo.
Phone: 455-95-32, 455-96-29
Directions: Rechnoy Vokzal metro station, buses No.90, 200, 270, 475, 673; tram No.58 to the 15th stop, Taxopark
Aum Shinrikyo
Aum Shinrikyo was organized in 1987 by His Holiness the Teacher Shoko Asahara, Sprit of Truth, who achieved ultimate freedom.
The main centre is located in Japan, but there are a large number of branches all over the globe: in Sri Lanka, Bonn, New York. One has recently opened in Moscow. The teaching of Aum Shinrikyo embraces the teaching of Mahayana Buddhism, Tibetan esoteric Buddhism, Indian yoga, and Taoism, it does not contradict the teaching of Jesus Christ.
Freedom from illness and suffering, earthly happiness, and Freedom and Enlightenment — these are the three forms of Salvation that Aum Shinrikyo preaches

And, finally, to the briefest notice:

Magic and sorcery. Cheap.

This offer of inexpensive magic was written on a tiny scrap of notebook paper measuring only 3 x 11 cm.

Ultimately, all these messages promise people an easy way to happiness. The next ad is unique in that it offers a panacea for almost all types of social 'ills.' It promises ways of leaving behind family and business troubles and finding universal happiness and spiritual peace. It tempts the reader with visions of lost hope restored, alongside remedies for incurable diseases:

Village magic of love, happiness, health, and success
Hereditary healers and psychics with 25 – 30 years of experience.
We will return happiness and emotional peace to your home!
ALCOHOLISM (highly effective, drug-free treatment, unique method),
can be undertaken without notifying the patient (for those who have
given up).
Very successful at:
Family problems, love, loneliness.
Providing good business sense.
Searching for lost people.
Helping dysfunctional families, problems at work, neutralising enemies.
Powerful lifting of negative consequences of witchcraft, family curses,
the evil eye (including weddings and death) and determining the nature
of spells and by whom they have been cast.
Charms for those who pine, protective charms, psychological
orientation.
Divining rods.
Bioenergetic healing with physiological purification of all systems
and illnesses.
Neuroses, including vagitative-vascular dystonia, insomnia, enuresis
(bed-wedding), stuttering, depressions.
Final stages of neoplasms, when specialists are unable to help.

All types of fortune-telling: cards, Tarot, coffee grounds, chiromancy, and computer-assisted astrology.
Cleansing rooms of evil spirits. Will make house calls.
Training in chiromancy and fortune-telling

Like psychics, chiropractors may also inherit healing abilities:

Hereditary chiropractor heals using the Kasyan method. Call 158-41-11

These notices are so widespread that they even inspire parodies among computer geeks. This does not diminish the commercial value of the ads. On the contrary, it works to their advantage, the humour helping to attract more customers:

Computer Watch
Novo-Peredelkino[59]
1. Charms for Windows™, software sorcery
2. Healing and replacing of possessed hardware
3. Taking away the evil eye and computer viruses
4. Psychic readings through the Internet
5. Buying and selling second-hand artefacts
We're close by, and we're cheaper!

International messiahs have also visited Russia. I couldn't comment on their degree of holiness, but here are some comments from local readers scrawled over the original ad (shown in brackets):

The Sports and Concert Arena
8 Gagarina Prospekt
The American (HORNED) pastors, Billy Joe & Sharon Dougherty
September 6, at 7:00 p.m.
Free Christian literature and children's books
(DON'T) Come and God will change your life!

Unlike small sects and marginal religious communities, large orthodox religious organisations are sometimes inclined not to try to attract parishioners, but rather to limit access to their churches for people who do not observe elementary religious norms. The following notice was displayed on the wall of Kazansky Cathedral in Red Square:

Rules of behaviour in the cathedral
1. You may not enter the cathedral
— if you are wearing shorts (and beach T-shirts)
— with ice cream and balloons
— if you are wearing miniskirts, bicycle shorts, or beach attire
2. Regardless of age, men must take off their headgear; women must cover their heads with kerchiefs.

Naturally, since I never leave home without my balloons, I am forbidden from ever entering this particular Russian Orthodox church.

59. A district of Moscow

This last ad is from a student dormitory in the city of Tartu, Estonia:

We offer an easy ride to other worlds. With the help of our project holding evening courses in meditation and other miscellaneous Zen Buddhisms, you will be able to travel through time and space, make friends with Buddha, and gain easy access to the astral plane and all that. The evening classes of extrasensory practitioners are led by your Magician and Instructor, I. Fart A'Lot and Alex the Levitator, Professor of Black Magic and the Great Ritual, Materializer of Spirits and Distributor of White Elephants, who kills bedbugs with his gaze and collects empty bottles by willpower alone. Don't mess with Buddha!

PUNKS, ROCKERS, AND ARTISTS

Male. Will sing anything. Hair 40 cms long. Vakhtang.

Often, people use self-made ads to organize themselves into informal groups with the aim of performing collective activities. The most prominent examples of these are ads by rock musicians:

The DBZh band is looking for musicians.
Preferably dumb naked babes.
Ph.: 177-79-35
Vova
We play PromStroy Punk.

Ads like this are primarily found in rock clubs, cafés, and other gathering places. I collected a number of examples of this type of ad in the vicinity of the first Russian rock club, which I was a member of in the early 1990s. Most ads were posted on the walls of the shop (located in the same building), which belonged to one of the founders of the club, Sergey Firsov:

A 19-year-old guitar player would like to join a band
that plays in one of these styles:
Post punk (preferable)
Punk
Industrial.
Existing material is desirable.
Technical-school kids don't bother to reply!

Looks are of vital importance in this area:

Male. Will sing anything. Hair 40 cms long. Vakhtang.

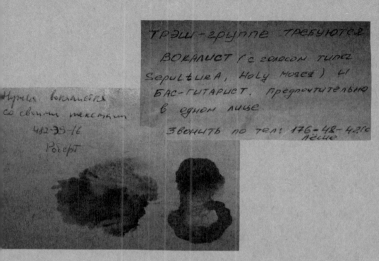

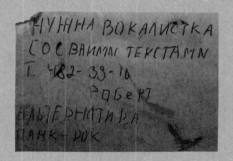

The entire life of young rock bands depended on such ads. They were a means of forming groups and looking for like-minded musicians:

Trash band looking for
singer (with a voice like Sepultura, Holy Moses)
and bass player.
Preferably one person who can do both.
Call 176-48-42
Lyosha

In the music world these ads became the primary means of recruiting band members:

Needed: female vocalist with her own lyrics 482-39-16.
Robert. Alternative, punk rock

Usually, the musical orientation of the bands was specified in the ads. These descriptions could often be precocious:

We are looking for a guitar player, violin player, and a drummer. Style: lyrical drama and comedy of life put to music. Lyrics in Russian. The music uses elements of classical, jazz, and rock. Experience in oraingement [sic] *is a plus. 233-39-26 Anna*

In those days, musicians were extremely poor and few of them had their own instruments:

Band playing neo-folk rock (national rock) needs a bassist with his own instrument...

This method of communication was very lively, ads were abundant, and venues sparse. For this reason more fully-fledged dialogues began to take place on these walls:

Trash band is looking for a drummer. Ask the shop's management.

Handwritten over this:

Hey, Vich! I found one. Kisych.

As a rule, posters for the concerts of all the rock bands were self-made. They were handwritten and photocopied. This made them look more like ads than posters:

*Poligon club
Gorkovskaya metro station, tram numbers 6, 31, 63
Red October House of Culture
8 Blokhina St.
Metal Music Night
Third Super-Festival of extreme music
New Year's Eve Satan's Ball
30th December, 9:00 p.m.*

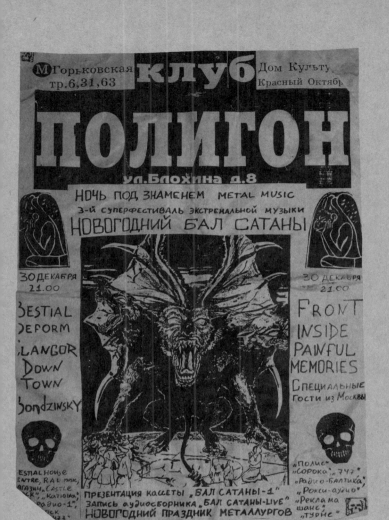

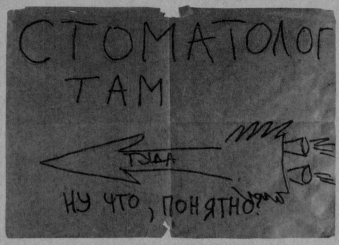

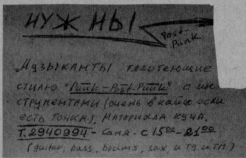

Not far from the rock club Pushka,[60] I borrowed what is now a historical document:

Art Clinic
New exhibit of that same Kirill Miller
Russian erotic attractions from 2:00 p.m. to 9 p.m.
every day except Monday
10 Pushkinskaya St. Drugstore is open

I also removed the following notice from the same place:

Don't panic! Read The Mitki News!

This was an ad posted by the Mitki[61] art circle, which comprised almost twenty artists, including Dmitri Shagin, Alexander and Olga Florensky, and Vladimir Shinkarev.

60. Based at 10 Pushkinskaya Street, it was also a large squatters' dwelling, where dozens of prominent artists lived for many years and organized exhibits, performances, and other art related events.
61. Mitki are a diverse group of artists based in St. Petersburg.

Chain letters fall into three catégories: those distributed by mail, those circulated on the Internet, and street notices. Here is the text of one such chain letter found on a St. Petersberg lamp post in 1995:

A letter from parallel worlds. The original letter is in Aiverpool [sic]. *Receiving this letter will bring you luck. Send the letter to someone you want to make happy. You have to believe in it; it all depends on you. This letter began its existence in 1284. It was translated into Russian at the beginning of the 20th century. An ailing peasant woman by the name of Kruglova first received it. Four days later, she found a treasure, next she married a prince, then she became a millionaire in America. In 1937, Marshal Tukhachevsky received the letter and burned it. Four days later he was tried and executed. In 1921, C. Doyle failed to make copies of this letter and his hand was amputated following a car crash. In 1964, Khrushchev received the letter at his dacha and threw it away. Four days later, he was thrown out of the party by his comrades. In 1990, Alla Pugacheva distributed 20 letters, she signed a contract with a foreign company and two months later received $4,000,000. There are many such examples. In 1927, Dante received the letter and handed it to his secretary to copy, a few days later he won $200,000. Andervs* [sic] *broke the chain and died a few days later. Rodin received the letter and did not copy it, soon after this his baby was born sick, and his wife died in childbirth. He then sent twenty letters and the doomed child got better. Do not for any reason tear up the letter. Take it seriously and copy it exactly without changing the words.*

XXX316–XXX31615–15 SD7–9–X K–XX–XII–2X–NX

These signs will bring you luck.

This letter has gone around the world 99 times. And now happiness and luck should be visiting your home. Send it to your friends and wait a few days. Do not send money — happiness can't be bought. Make twenty copies and luck will come to you. This isn't a scam. You will be surprised!

The range of topics in chain letters is remarkably broad: stolen children, foreign murderers, singers, figure skaters, madmen, sect members, assassination attempts, cannibalism, castration, resurrection, asceticism, and even the crucifixion of dismembered sexual organs. In these letters, divine retribution and demonic revenge loom large. The message is thrust on the reader like a command from the other world. The messages show traits of various other genres: prayers, charms, sermons, scriptures, legends, spells, curses, and even protective magic. The addressee finds himself in the possession of a magical, multifunctional 'thing.' If the reader does as he is bid, the letter will become a protective charm, a talisman; through it dark forces will come to the aid of the reader. If, however, he fails to follow the instructions, the letter will become a curse, a punishment. By copying the letter, the reader receives absolution and a blessing from the higher powers. The letter always contains in a compressed form, the legend of its origin. The text of these letters references the supernatural traits of the letter itself. In his article *Holy Writ as a Phenomenon of Traditional Folklore*,[62] V. Lurie demonstrates that chain letters are derived from Scriptures and Divine Epistles. He also makes reference to a study by M. Belyaev on divine books, in which the author traces the tradition of all kinds of messages to antiquity, ancient Assyro-Babylonian and Egyptian stories about heavenly books, and Jewish mysticism. The *Book of Enoch* had a definite influence on this phenomenon. Thus, even early Christians were familiar with the genre of 'heavenly letters.' A. Veselovsky in his *Research in the History of Development of the Christian Legend* (1875–1877) also wrote about early Christian epistles. As early as 584, Licinian of Cartagena reproached one of his more gullible brothers in faith about 'letters of renunciation.' It seems that 'letters of renunciation' were also well known in the Middle Ages in Europe, where they were a form of early Christian homily. I believe these are street notices in their most ancient form, evidence of a centuries-long tradition.

62. V. Lurie, *Holy Writ as a Phenomenon of Traditional Folklore.* Russkaya Literatura, 1993. Issue 1.

ДОРОГИЕ ЗЕМЛЯНЕ!

ВЫ СОПРИКОСНЕТЕСЬ СО СЛОВОМ

ВИССАРИОНА,

ЯВЛЯЮЩЕГО

ПОСЛЕДНИЙ ЗАВЕТ
ОТ ПОСЛАВШЕГО ЕГО
ОТЦА НЕБЕСНОГО

19 „И дам вам Слово, которое будет
судить вас в последний день" в **19**00 ч.
ЯНВАРЯ

Начало в 19^{22} час. **ДК ЛЕНСОВЕТ** Вход свободный

М. ~~Пеперой~~ Петроградская

Институт Знаний о Тождественности
"Миссия Чайтаньи" приглашает на видеолекцию
Сиддхасварупананды Парамахамсы

ИСТИННЫЙ СМЫСЛ ЙОГИ

18 апреля 18.00

м. «Охотный ряд», Брюсов пер. 8/10,
«Дом композиторов», малый зал
Тел. 264-01-96

Вход свободный

The Russian notices contained in this book are echoes of a completely mythological world. They exhibit a kind of thinking that is opposed to a traditional historical, scholarly, or scientific position. For example, the entire linguistic foundation of political notices is limited to a narrow circle of strategically non-productive metaphors inherited from the past. Working within this paradigm, the authors of these notices can only raise 'the people' to fight 'chaos' and 'world evil.' Indeed, in the world of fairy tales anything is possible. If there is no Evil, it must be invented; if there are no Victims, they must be created. In this way, an urban street becomes an unreal semantic space. From a sociological point of view, it is not a public space, but an objectification of one — an illusion. In the final analysis, however, all these mythological metaphors become the foundation for very real, completely ritualized, exercises in power.

As for the readers of these notices, they have the illusion of involvement in the social fabric. A person who engages in writing a street message (even if it is a simple autograph), or who reads a political pamphlet, acquires the illusion of a certain social status. The street gives people hope, functions as an outlet for mass fears, and gives rise to phantasms and incipient desires.

Most of these endlessly repeating street messages bear no rational semantic burden; in other words, in the strictest sense they are not messages at all. They resemble, to a large degree, the phenomenon of love, hate, or other feelings and emotions. The politicians confess their love for the people, the people confess their love for the president, mothers for children, men for women, and ordinary men for lost objects. But *I love you* is not a message at all. It does not convey meaning, but is linked to a situation of extremity. As Roland Barthes has said, quoting Lacan, in *A Lover's Discourse: Fragments*, 'it is that situation in which the subject freezes in a mirrored relation to the other.' The author of the

notice is usually speaking to himself, using his inner source of pleasure, which seems (only to him) to be external. It is his own symbolic image, which is perceived by him to be a source of pleasure, lying beyond his own boundaries. His true *I*, however, is located on the other side of the text, but it cannot be reflected back. As Jacques Lacan said in one of his seminars, 'the wall of language separates the subject from Others, the true Others.' And this external, unperceived source of the ideal language placates both the author of a love letter written on the wall, and the president who informs his people about his love for them, because both of them have childish doubts about their identity, about the very fact of their existence. Lacan stated that 'to be desired is more important that to be satisfied.' The symbolization of the subject occurs when the subject is desired. When he is unwanted, the desymbolization or destruction of the subject takes place. If the subject (the president, for example) is desired, he exists. And when he is not desired, he turns into a symbolic 'nothing.' At the same time, satisfaction, roughly speaking, is just giving form to meaning; that is, giving meaning to series of objects.

The illusion that 'I don't want anything anymore' is very important; but the 'I don't love you' model can simply kill. In Russia, all social relations unfold on the plane of love/hate, good/evil. It is a completely fairy-tale world, a patriarchal and mythological world: the people love the emperor, the emperor loves the people.

But the demythologized History of the Future will hardly be capable of hearing these voices. For history, all of these little dirty scraps of paper with strange, sometimes completely inane scribblings, pasted all over Russia in the most marginal spaces, are but an echo of fairy-tale chaos.

Notes from Russia itself is only 'a voice calling in the wilderness.'[63]

63. Isaiah 40:3

Acknowledgments

My thanks to Evgeny Umansky and Julia Gnirenko who have supported
and promoted this endeavor, Yury Nikich and Sergey Kovalevsky, who
introduced the project to the museum world. A special thank you to Julia
Goumen and to FUEL for deciding to take on such an unorthodox project.
I am also eternally grateful to artist Igor Johanson, photographer Boris
Bendikov, and poet Mikhail Boldumann, who have donated some
valuable pieces to the Museum. And to Vadim Bogudlov, who generously
gave me the sign from the door of his own clinic. Russian text translated
by Gannon & Moore Translations: www.GMTranslations.com

PHOTOGRAPHY Alexei Plutser-Sarno, FUEL
TEXT Alexei Plutser-Sarno

DESIGN AND EDIT Murray & Sorrell FUEL
TRANSLATION Polly Gannon and Ast A. Moore
CO-ORDINATOR Julia Goumen

First published in 2007

Murray & Sorrell FUEL ©
Design & Publishing
33 Fournier Street
London E1 6QE

www.fuel-design.com

© Alexei Plutser-Sarno

Printed in Hong Kong

Distributed by Thames & Hudson / D.A.P.
ISBN 978-0-9550061-7-3

Other books published by FUEL

BibliOdyssey
PK
ISBN 978-0-9550061-6-6

Match Day • Football Programmes
Bob Stanley & Paul Kelly
ISBN 978-0-9550061-4-2

Ideas Have Legs
Ian McMillan Vs Andy Martin
ISBN 978-0-9550061-5-9

Home-Made • Contemporary Russian Folk Artifacts
Vladimir Arkhipov
ISBN 0-9550061-3-9

Russian Criminal Tattoo Encyclopaedia Volume II
Danzig Baldaev
ISBN 0-9550061-2-0

Fleur • Plant Portraits
Fleur Olby
ISBN 0-9550061-0-4

The Music Library
Jonny Trunk
ISBN 0-9550061-1-2

Russian Criminal Tattoo Encyclopaedia
Danzig Baldaev
ISBN 3-88243-920-3

For more information visit:
www.fuel-design.com

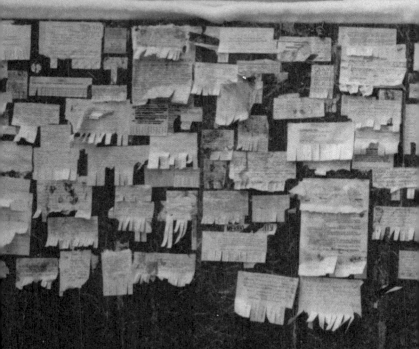